Da Vinci's Vitruvian Man Hides a Pentagram and a Serpent God. Basic Model Copied From Mars?

To
Lenka

From Arthur

D1205828

Arthur Raymond Beaubien

epiphi productions

Da Vinci's Vitruvian Man Hides a Pentagram and a Serpent God. Basic Model Copied From Mars?

ISBN 9780994032140

 epiphi productions
Ottawa, Ontario
Canada

Library and Archives Canada Cataloguing in Publication

Title: Da Vinci's Vitruvian man hides a pentagram and a serpent god. Basic model copied from Mars?
 / Arthur Raymond Beaubien.
Names: Beaubien, Arthur Raymond, 1942- author.
Description: Includes bibliographical references.
Identifiers: Canadiana 20210204974 | ISBN 9780994032140 (softcover)
Subjects: LCSH: Leonardo, da Vinci, 1452-1519. Vitruvian man. | LCSH: Leonardo, da Vinci, 1452-1519—
 Criticism and interpretation.
Classification: LCC NC257.L4 A78 2021 | DDC 741.092—dc23

Cover design © by Arthur R. Beaubien. Da Vinci's Vitruvian Man superimposed on a Masonic checkered floor.

Dedication

To the Divine Mother

Acknowledgements

The author wishes to express his gratitude to Gayle Peterson and their daughter Kery for giving an abundance of meaning to his life. He also wishes to thank George A. Neville for his invaluable enduring friendship, support, and his many helpful comments in his review of this manuscript.

Contents

Preface

This book demonstrates that the primary purpose of Leonardo Da Vinci's Vitruvian Man drawing was not to show that the human body fits a square and a circle. Nor was it about demonstrating that the body fits the many other dimensions which the Roman architect Vitruvius had worked out in his treatise *De Architectura* for the natural body shape in the first century BC. Although most of these were well satisfied with considerable accuracy by the drawing, Da Vinci had more important agendas to accomplish with the Vitruvian Man. The square, the circle and the notes about the body dimensions (which were based on the work of Vitruvius) served as distractions to deflect our attention from the real intent behind his drawing. And it worked extremely well. It is now more than 500 years since he made his drawing and no one has noticed the anomalies that hide a truly dark revelation.

Another distraction that Leonardo used with the Vitruvian Man drawing was his novel (and somewhat erroneous) observation, stated on his drawing, that "If you open your legs so much as to decrease your height 1/14 and spread and raise your arms till your middle fingers touch the level of the top of your head you must know that the centre of the outspread limbs will be in the navel and the space between the legs will be an equilateral triangle." He also observed (more correctly) that "the beginning of the genitals marks the middle of the man." Da Vinci made his own measurements of the human body from male models in which he disagreed with Vitruvius in the length of the foot and in the distance from the hairline to the top of the breast.

Almost as a tribute to Da Vinci's cleverness at distracting us, many scholars have focused on trying to construct models to account for the relationship between the side length of the square and the diameter of the circle in Da Vinci's drawing. These are nicely summarized by Murtinho, 2015.[1] Murtinho states that the commonly accepted values for these 2 geometric figures are 110 mm for the radius of the circle and 181.5 mm for the side length of the square. This gives a ratio of 0.6061. Many have focused on the inverse of the golden ratio (0.6180) as being the intended relationship. Others have suggested the ratio of the important integers of 6 and 10. Still others suggest that the relationship between the circle and square can be explained by a heptagon (Helbing), an octagon with a side length equal to the side of the square (Lionel March), and a double vesica pisces (Murtinho). All of these models are wrong.

This book presents a very simple model of the Vitruvian Man which not only explains the true relationship between the square and the circle, but also nicely incorporates a pentagram. It also shows that Da Vinci

drew his figure to secretly fit the undrawn pentagram by making very slight changes to the model which everyone has overlooked. Even more intriguing is Da Vinci's boldness in designing the Vitruvian Man to fit a hidden image of the serpent god Ningishzida, and in the process, possibly revealing that he was gay.

In the book *Intelligent Mars I: Sacred Geometry of the Mountains. Did Da Vinci Know?*[2] I created a theoretical model of the Vitruvian Man based on Da Vinci's writing. I also added a pentagram to the model. When the model circle was adjusted to fit Da Vinci's circle it was found that Da Vinci's square was about 1.22% smaller than my model's square which was constructed large enough to contain all the stars points of the pentagram. With Da Vinci's smaller square, the tip of the upper star point of the model pentagram went above the head of the Vitruvian Man rather than fitting within the square.

The purpose of the model was to create a Vitruvian Martian which could be fit to the 4 giant Martian mountains of Olympus Mons, Ascraeus Mons, Pavonis Mons and Arsia Mons. I discovered that a pyramid in the shape of a pentagram located between Olympus Mons and Arsia Mons played a very important role in the construction of a virtual Vitruvian Martian. I called this pyramid the Pentagram Pyramid. Its NW star point pointed to my measure of the centre of Olympus Mons. Its NE star point pointed to a location on the line between Olympus Mons and Pavonis Mons which divided the line in a proportion very similar to the proportion created by the navel of the Da Vinci Vitruvian Man with regard to the height of the man. This led me to construct a Vitruvian Martian using an estimate of the Da Vinci Vitruvian Man proportions rather than my own model.

The new theoretical model which this book presents fits Da Vinci's Vitruvian Man so successfully that I decided to use it to refit the Martian mountains. But I found that the NE star point of the Pentagram Pyramid no longer pointed to the location of the navel (i.e., the circle's centre) of the new model. This led me to look for another way in which the Martian architects could have located the position of the navel. My answer was found on the top of a giant ramp which penetrates the Pentagram Pyramid.

The success of the new model in fitting both the Martian mountains and Da Vinci's Vitruvian Man suggests that Da Vinci copied the model from Mars to use for his drawing. This is not as farfetched as it may seem since there is evidence that knowledge of Mars existed on Earth long before Da Vinci's era.[2,3] This knowledge was probably passed on in elite circles comprised of Freemasons such as Vitruvius and Da Vinci himself. I now invite the reader to a very unique explanation of this famous

drawing which reveals very important messages that were missed by scholars for centuries and were probably known only to privileged members of secret societies.

Arthur R. Beaubien

References

1. *Leonardo's Vitruvian Man Drawing: A New Interpretation Looking at Leonardo's Geometric Constructions.* Vitor Murtinho. Nexus Netw. J., 17:507–524, 2015.

2. *Intelligent Mars I: Sacred Geometry of the Mountains. Did Da Vinci Know?* Arthur Raymond Beaubien. Epiphi Productions, Ottawa, Ontario, Canada. 2015.

3. *Intelligent Mars III: Aum and the Architect.* Arthur Raymond Beaubien. Epiphi Productions, Ottawa, Ontario, Canada. 2020.

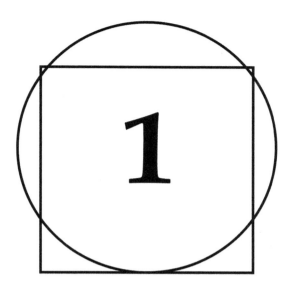

The Square is Determined by the Circle

Although many scholars have attempted to construct models to account for the relationship between the side of the square and the diameter of the circle in Da Vinci's drawing, it seems that they all have missed the most obvious solution. The circle is made up of 360° which can be split into 4 sections using 4 radius lines: 3 sections of 100° each and 1 section of 60°. In Fig. 1.1a, one pair of the radius lines creates an angle of 100° above the centre of the circle and a second pair creates an angle of 60° below the center. The pairs are separated by 100° on both sides of the centre. In image b, a fifth radius line splits the angle created by the bottom pair of radius lines in half. A square can now be constructed with 2 horizontal sides and 2 vertical sides. This is accomplished by joining the ends of the upper pair of radius lines (image c). When the 5th radius line is extended upwards to reach the midpoint of the upper horizontal line in image d, a vertical line is created which gives the length s of the side of the square. The square can now be constructed by centring horizontal lines of length s at the top and bottom of the vertical line. The ends of these 2 lines can then be joined to form the vertical sides of the square (image e).

In Fig. 1.2, a right-angled triangle (dashed lines) is formed at the top right area of the model from Fig. 1.1e. The sides of the triangle consist of (1) a line marking the height of the triangle extending from the centre of the circle to the middle of the top line of the square, (2) a line marking the top

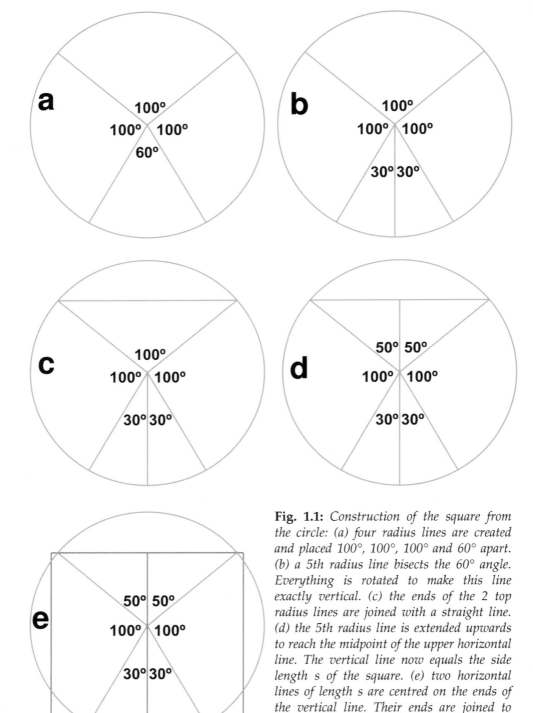

Fig. 1.1: *Construction of the square from the circle: (a) four radius lines are created and placed 100°, 100°, 100° and 60° apart. (b) a 5th radius line bisects the 60° angle. Everything is rotated to make this line exactly vertical. (c) the ends of the 2 top radius lines are joined with a straight line. (d) the 5th radius line is extended upwards to reach the midpoint of the upper horizontal line. The vertical line now equals the side length s of the square. (e) two horizontal lines of length s are centred on the ends of the vertical line. Their ends are joined to form the vertical sides of the square.*

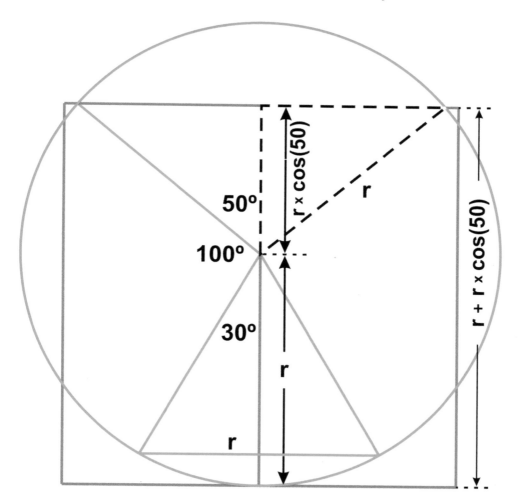

Fig. 1.2: *Basic theoretical model likely used by Da Vinci in the construction of his Vitruvian Man drawing. The square is completely defined by the size of the radius of the circle. The square side length is equal to the radius (r) of the circle plus r x cos(50). Since the 2 bottom blue-coloured radius lines are separated by 60°, when their 2 ends are joined, an equilateral triangle is formed with all sides equal to r.*

line of the triangle extending from the midpoint of the top line of the square to the intersection of the circle with the square, and (3) the hypotenuse of the triangle formed by a radius (r) line of the circle. The trigonometric formula for the cosine of the 50° angle of the bottom vertex of the triangle is:

$$\cos(50) = \frac{\text{length of triangle's vertical side}}{r}$$

This formula can be rearranged to give the length of the triangle's vertical side:

length of triangle's vertical side = r x cos(50)

Thus the square's side length s is equal to the radius r of the circle plus r x cos(50), where cos(50) = 0.6428. Notice that the side length of the square is fully defined by the radius of the circle without error. Its relationship to the circle does not involve the golden ratio φ or geometric figures such as a heptagon, octagon or vesica pisces.

The 2 bottom blue-coloured radius lines in Fig. 1.2 are separated by 60°. When their lower ends are joined, they form an equilateral triangle with a side length equal to r. Hence, the equilateral triangle is also fully defined by the circle radius r, and satisfies Da Vinci's assertion that "the space between the legs will be an equilateral triangle".

Fit of the Theoretical Model to Da Vinci's Drawing

Once my theoretical Vitruvian Man was completed, I sized it to fit the Da Vinci drawing (Fig. 1.3). The drawing used was taken from a book[1] published in 1930 so as to avoid copyright disputes from those who do not respect the concept of public domain. Like all photographic reproductions, it had to be first corrected for lens distortions before being used for measurements. The procedures used are too complex to describe here. A fully distortion-free reproduction of the original drawing (assuming that the original has not been distorted with the passage of time) could be obtained with a scanner which is accurate to several hundred dots per inch, but this probably would endanger the original due to strong light exposure. I assume that a scanned reproduction is not available, since all of the reproductions I examined have a certain amount of distortion. My corrected reproduction compared very favorably to the least distorted reproductions that I could find. I also digitally removed all markings outside of the human body except for the circle and the square.

The model was fit by aligning the square and circle to the Da Vinci drawing as best as I could, balancing out all of the occurrences of slight deviations from the model. I then proportioned everything so that the diameter of Da Vinci's circle in the drawing had a size of 220 mm which was the size measured for the diameter of the Da Vinci circle in the original drawing (Fig. 1.3).[2] When all of this was done, I found the model circle (blue circle in Fig. 1.3 and in Fig. 1.3 inset) to be very slightly larger than my best fit to the Da Vinci circle. Its diameter of 220.511 mm would have to be reduced by 0.511 mm to align perfectly with the Da Vinci circle

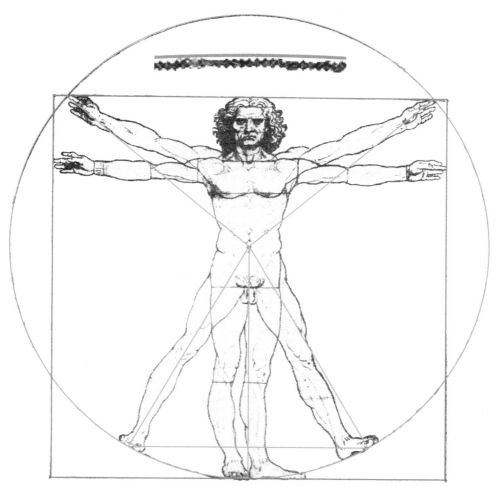

Fig. 1.3: *The theoretical model fitted to Da Vinci's drawing. Notice how all 5 radius lines correspond to the extremities of limb positions. The model circle is only 0.23% larger than Da Vinci's circle (see magnified circle segments in insert). Photo modified from McMurrich.*

Table 1.1: *Comparison between the theoretical model and the Da Vinci drawing.*

	Model (mm)	Da Vinci (mm)	Difference from model (mm)
Circle diameter	220.511	220.000	-0.511
Distance of circle centre from top of head	70.871	71.126	0.256
Side of square	181.126	181.126	0.000
Centre of square (mm from start of genitals line)	0.000	0.000	0.000

(Table 1.1). However, that would cause the model square to be too small to fit Da Vinci's square. The centre of the Da Vinci circle is also 0.256 mm lower than the centre of the model circle. Curiously, the center of the navel in Da Vinci's drawing is about 0.525 mm lower than the model circle centre and about 0.270 mm lower than the centre of the Da Vinci circle. The side length of the model square is 181.126 mm which is 0.374 mm smaller than the 181.5 mm value measured for the original drawing of the Da Vinci square.[2] However, the estimates of Da Vinci's circle and square size from the original drawing were based on a single measurement of the circle radius and a single measurement of the width of the square (see Fig. 4 in Murtinho[2]) whereas my measurements were based on an average fit over the entire course of the square and of the circle. Da Vinci's square and circle were not perfect geometric constructs and they showed significant deviations over their course from being a perfect circle and a perfect square.[2] I found that increasing the size of the model square would deteriorate the already good fit that the model square provided. The centre of this size of model square aligned perfectly with Da Vinci's line which marked the start of the genitals. Increasing the size of the square would put the centre of the square above this line since the lower side of the square has to align with the circle circumference, requiring the upper side of the square to be placed higher to accommodate the increase in size. Thus the theoretical model is best fit to Da Vinci's Vitruvian man when the model square is aligned to the Da Vinci square, requiring only that the model circle diameter be 0.511 mm larger than Da Vinci's circle.

Another very important observation is that the 5 radius lines of the model align to all of the extremities except, of course, the hands of the horizontal arms which are fitted to the square rather than to the circle. But just how perfect is this? A closer look at the middle finger of the right upper hand shows that the centre of the finger is higher than the radius line which passes along the bottom edge of the finger (Fig. 1.4, left image). The opposite situation is seen for the middle finger of the left upper hand (Fig. 1.4, right image). Here the radius line passes along the top edge of the finger rather than through its middle. Also, the top side of Da Vinci's square is bent downwards by a significant amount in this region.

In summary, a very simple model using 5 radius lines of a circle can be used to construct a square which has almost exactly the same relationship to the model circle as Da Vinci's square has to the circle which he drew for the Vitruvian Man. In addition, the 5 radius lines, which were separated by 100°, 100°, 100°, 30° and 30°, correspond very closely to the positions of limb extremities. There were only small discrepancies, with the diameter of the model circle being 0.511 mm larger than that of Da

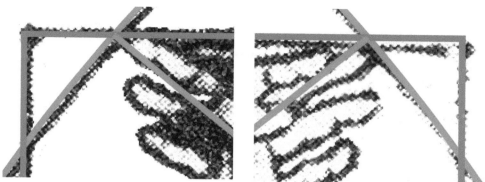

Fig. 1.4: *Left: Image of the fingers of the upper right hand. Note how the model radius line runs along the lower edge of the middle finger. Right: Image of the fingers of the upper left hand. Note how the model radius line runs along the upper edge of the middle finger. Note also how Da Vinci's square dips markedly lower in this region.*

Vinci's circle, and the upper radius lines aligning with an edge rather than the middle of the third fingers of the upper pair of arms. This suggests that my new theoretical model was the one used by Da Vinci.

At first glance, it would seem that the deviations of Da Vinci's drawing from the theoretical model could simply be attributed to normal inaccuracies arising from using instruments which were primitive in relationship to modern day instruments such as a computer. However, this would greatly underestimate Leonardo's exquisite competence as an artist, draftsman, architect, engineer and anatomist. The next chapter will show that these deviations were made intentionally to have the Vitruvian Man drawing point to a fourth geometric shape which it fits in addition to the square, the circle and the equilateral triangle.

References

1. *Leonardo Da Vinci The Anatomist (1452-1519).* J. Playfair McMurrich. The Williams & Wilkins Company, Baltimore, 1930.

2. *Leonardo's Vitruvian Man Drawing: A New Interpretation Looking at Leonardo's Geometric Constructions.* Vitor Murtinho. Nexus Netw. J., 17:507–524, 2015.

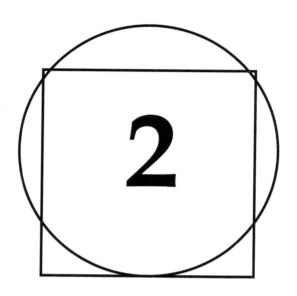

A Hidden Pentagram

I t is inconceivable that Leonardo Da Vinci would not try to fit the human body somehow to the golden ratio = 1.6180. He was well aware of this ratio since he provided the illustrations for a work published in 1509 by Loca Pacioli with the title of *De Divina Proportione*. In this work there are illustrations showing pentagons with lines joining 2 nonconsecutive vertices. These lines are in golden ratio to the side length of a pentagon (a geometric figure with 5 equal sides) which itself is a component of a pentagram. The big question is whether or not Da Vinci tried to fit the human body to a pentagram with the Vitruvian Man drawing.

A contemporary of Da Vinci, Heinrich Cornelius Agrippa (1486 - 1535), produced a drawing of a human body fitted to a pentagram which was published in 1533, well after Da Vinci's drawing which was produced around 1490. Despite the difference in date, Agrippa's drawing illustrates that the concept of fitting a human body to a pentagram was present around the same time frame. From Agrippa's drawing (Fig 2.1), we see a human body fitted to a pentagram by placing the head and 4 limbs at the star points of the pentagram. The centre of the circle fitting the pentagram occurs at the intersection of the horizontal and vertical diameter lines, and is situated at the base of the penis. I determined the centre of the pentagon which lies in the middle of the pentagram, and indicated this centre with a red cross. Both the centre of the pentagon and the centre of the circle should coincide, but the centre of the pentagon occurs slightly higher than the

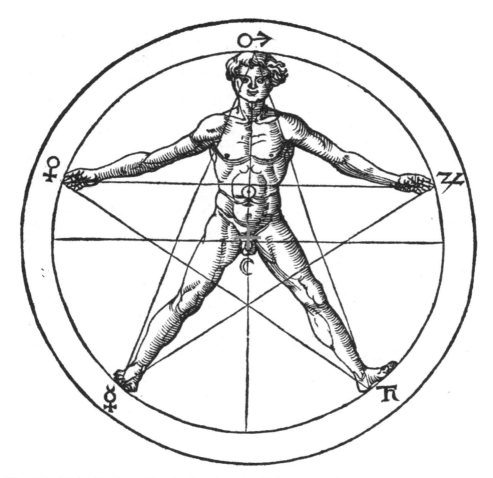

Fig. 2.1: *Heinrich Cornelius Agrippa's early 16th century drawing of a man fitted to a pentagram, taken from his book* De Occulta Philosophia Libri Tres. *The circle is centred at the base of the penis while the pentagon inside the pentagram is centred slightly higher (see red cross). This indicates that the pentagram is distorted. Courtesy of Jörgen Nixdorf, Wikimedia Commons.*

centre of the circle. This indicates that Agrippa's pentagram is distorted. What intrigued me most about Agrippa's drawing was that the center of the circle enclosing the pentagram was located right at the beginning of the male genitalia, thus making it a powerful symbol for fertility. If the figure were female, the center would occur close to the point of exit of the newborn child from the vaginal opening, thus symbolizing the most profound act of creation available to humanity. The pentagram, when fitted to the human body, therefore very powerfully represents the female and the male as procreators of a life form that has the intrinsic shape of a

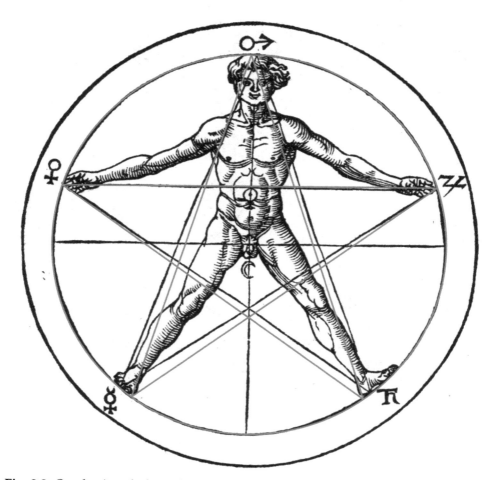

Fig. 2.2: *Overlay in red of a perfect pentagram on Agrippa's drawing. Note that the head and upper star point are slightly off-centre to the man's left, and that the feet are spread too far apart to properly fit a true pentagram. Courtesy of Jörgen Nixdorf, Wikimedia Commons.*

pentagram. The use of the pentagram for a fertility symbol makes good sense since the structure of the pentagram embeds the golden ratio in many ways, and the golden ratio is found everywhere in nature.

When I overlaid a perfect pentagram on Agrippa's diagram, I found more distortions from the correct geometric shape other than a misplaced pentagon centre (Fig. 2.2). Only the star points fitting the hands are in the correct position. The star point fitting the head is displaced to the man's left a bit. The upper half of the vertical diagonal line is bent to the man's left as well. Also the star points fitting the legs are too far apart. Such imprecision would never have been tolerated by a highly skilled artist and architect such as Da Vinci.

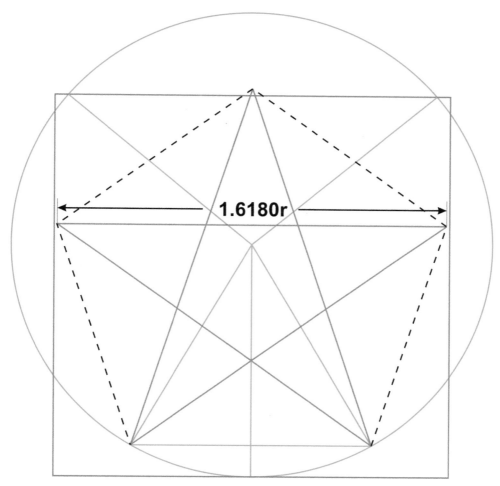

Fig. 2.3: *Construction of a theoretical pentagram to fit the Vitruvian Man. A pentagon (dashed lines) with a side length equal to the radius of the circle is first created which aligns with the bottom side of the equilateral triangle. It takes 5 straight lines to join all the nonconsecutive vertices of the pentagon. In doing so, a pentagram is created with each line of the pentagram having a length of the circle radius (r) x 1.6180.*

Theoretical Pentagram Model To Fit the Vitruvian Man

In order to fit the Vitruvian Man to a pentagram, the most obvious pentagram model to try involves using the 2 bottom vertices of the equilateral triangle for the tips of the 2 lowest star points of the pentagram. These coincide with the location of the spread-apart pair of feet. The pentagram is easily constructed by using the bottom side of the equilateral triangle as the bottom side of a perfect pentagon (Fig. 2.3). The pentagon is created by placing the other 4 sides (shown by dashed lines)

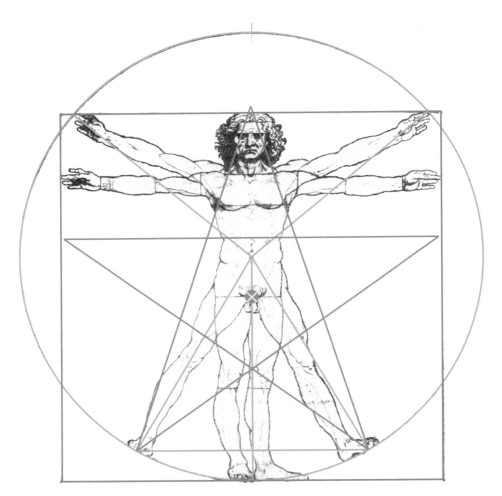

Fig. 2.4: *Fit of the theoretical pentagram to the Vitruvian Man. The 2 lower star points fit the spread-apart pair of legs. The 2 star points to the sides are well below the arms and don't quite reach the sides of the square. The upper star point lies slightly above the head. The centre of the pentagram is marked by a filled red circle. It lies 0.085 mm above the centre of the square marked by a yellow X at the base of the genitals.*

of length r (the radius of the circle) at angles of 108° from each other. The pentagram itself is then constructed by simply going around the pentagon and using straight lines to join every vertex of the pentagon with the vertex which is 2 vertices away in the same rotational direction. Each of the 5 pentagram lines thus created is equal to the circle radius r multiplied by the golden ratio φ (which equals 1.6180) since any diagonal joining 2 nonconsecutive vertices of a pentagon is equal to the side length times φ. The entire pentagram fits within the square except for the tip of the upper

star point which penetrates slightly beyond the top side of the square.

When the theoretical pentagram is fitted to the Vitruvian Man (Fig. 2.4), it can be seen that the tip of the upper star point protrudes slightly above the head. The 2 star points on either side of the man are well below the horizontal arms and do not quite reach the sides of the square. The 2 lower star points fit the pair of spread-apart legs and feet. When the drawing is sized so that Da Vinci's circle has a diameter of 220 mm, the centre of the pentagram (small filled red circle) occurs only 0.085 mm above the centre of the square (yellow X) at the base of the genitals. So the theoretical pentagram fits the Vitruvian Man extremely well. But did Da Vinci design the Vitruvian Man to fit this particular pentagram?

The answer to that question is a definite "yes" but in order to see this we need to examine the arms of the Vitruvian Man very carefully. First of all, let's look at the left image of Fig. 2.5 which shows a magnification of the hand of the right horizontal arm. The hand itself is oriented so that the palm lies somewhere between (1) lying on a perfectly vertical plane with the thumb bent down in front of the plane and (2) lying on a plane which makes a 45° angle with the vertical plane. The darkening of the palm and the base of the 4th finger suggests that the lower part of the palm is receded into the picture and hence the palm would be closer to the 45° angle plane than to a perfectly vertical plane. Now look at the middle and 4th fingers. They have an orientation which could only be achieved if the palm was facing directly down towards the floor. The tip of the middle finger is bent upwards so as to achieve a slightly greater height. If we look at the left hand in the right image of Fig. 2.5 we see that the arm and hand are significantly lower than the right arm and hand. This is also shown in Fig. 2.6 with the lines from the middle fingers extended to the vertical midline of the Vitruvian Man where they meet at different heights. At first this might seem to be an acceptable deviation in symmetry, but the

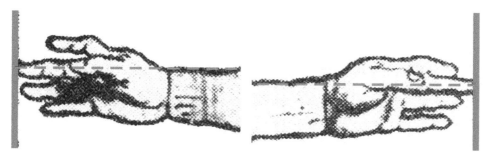

Fig. 2.5: *Left: The middle and fourth fingers of the horizontal right arm have an orientation possible only if the palm was directly facing the floor. Right: The middle finger of the left hand is substantially lower than that of the right hand. The right image is coordinated with the left image to show the correct relative height of the 2 arms.*

Fig. 2.6: *Horizontal lines from the middle fingers in Fig. 2.5 extended to meet the midline of the Vitruvian Man. Note how they are at different elevations. The vertical midline of the square is used for the body midline.*

impossible anatomical orientation of the middle and 4th fingers of the right hand give a clear signal that Da Vinci had a second agenda with the horizontal arms. Their purpose was not limited to demonstrating a fit to a square which has a side length equal to the Vitruvian Man's height.

It turns out that the middle finger of the right horizontal arm is midway between the top line of the model square fitting Da Vinci's square and the horizontal line of the theoretical pentagram. The horizontal dashed line is positioned to be equidistant from these 2 lines in the left image of Fig. 2.5 and in Fig. 2.6. Figure 2.7a shows the same line as a solid green line which is 30.748 mm from both the top line of the square and the horizontal line of the pentagram. The point where this line intersects the body midline was intended by Da Vinci to be a point of rotation (see red arrow in Fig. 2.7a).

The tip of the middle finger of the upper hand meets the intersection point of Da Vinci's circle and his square. This is clearly shown in the top left insert of Fig. 2.7b where green lines mark the average Da Vinci circle and the average Da Vinci square. If the intersection point of these lines is joined with a straight line (also green) to the point of rotation, an angle of 20.1246° is created with the horizontal line from the middle finger of the lower hand (Fig. 2.7b). It turns out that 20.1246° is equal to 9√5° which is a reference to the pentagram since 9 is 1/4 the size of the 36° angle of a star point of a pentagram, and √5 is a factor in the length of 2 pentagram star point sides minus the length of a star point base. The value of √5 is also a factor in the diagonal of a double square (i.e., 2 adjacent equal-sized squares creating a rectangle whose length is twice its width). Two double squares are created by the midline of the square (see Fig. 4.4, Chapter 4).

When the line from the middle finger of the upper hand is rotated counterclockwise by 9√5° about the point of rotation, it lines up with the horizontal line to the middle finger of the lower hand. Then if it is rotated counterclockwise by another 9√5° for a total rotation of 18√5°, its end exactly touches the horizontal line of the pentagram (Fig. 2.7c). Thus the horizontal line from the middle finger of the lower hand acts as a line of

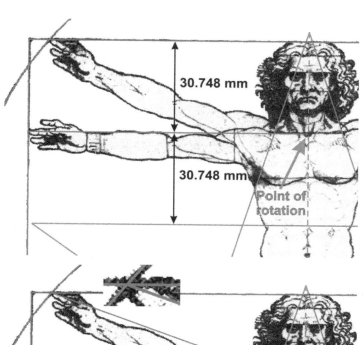

Fig. 2.7a: *The horizontal line from the middle finger of the lower hand to the body midline lies exactly midway between the upper side of the Da Vinci square and the horizontal line of the model pentagram. The intersection point of the line from the hand with the body midline is used as a point of rotation (red arrow).*

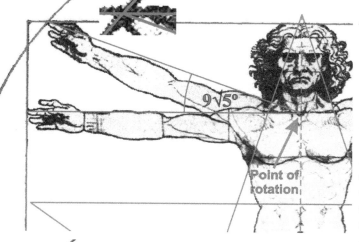

Fig. 2.7b: *The middle finger of the upper hand touches the intersection of the Da Vinci average circle with his average square (see inset). A straight line running from this intersection point to the point of rotation at the midline creates an angle of 9√5° with the horizontal line from the middle finger of the lower hand.*

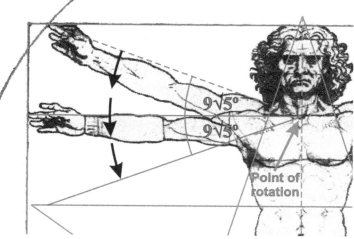

Fig. 2.7c: *If the line from the upper middle finger is rotated counterclockwise about the point of rotation by 18√5°, it creates a mirror image of the upper angle, and its distal end touches the horizontal line of the model pentagram. The horizontal line from the middle finger of the lower hand acts as a line of symmetry.*

symmetry between the line from the tip of the middle finger of the upper hand and its reflection which touches the horizontal line of the pentagram. In this way, the middle fingers of the 2 right hands are used as a device to reveal the presence of the hidden pentagram.

This is not the only angle of symmetry with respect to the right pair of arms. If we draw the line from the point of rotation to the intersection of the *model* circle with Da Vinci's average square, we create an angle of 20.0040° with the line of symmetry from the middle finger of the lower hand (Fig. 2.8a). The inset at top left shows a magnified view of the intersection of the model circle (blue) with the Da Vinci average square (green). When the line from this intersection point is rotated counter-clockwise by 20.0040° about the point of rotation, it lines up with the horizontal line from the lower middle finger. When it is rotated a further 20.0040° (Fig. 2.8b), it touches the horizontal line of the pentagram just like the reflected 9√5° angle line in Fig. 2.7c from the intersection of Da Vinci's circle and square. The angle of 20.0040° can be rounded down to 20° without a significant loss of accuracy. The number 20 is a powerful reference to not only the pentagram but also to the square since 20 is equal to 4 x 5 where 4 is the number of sides in a square and 5 is the number of star points in a pentagram. It therefore is highly likely that Da Vinci would have intended the 20° angle lines as well as the 9√5° angle lines, and these lines would be marked by the intersection of the square with the theoretical circle in virtual form. We shall see below that Da Vinci was well aware of the size of the model circle

Thus it seems that Da Vinci deliberately created his circle slightly smaller than that of the theoretical model to fit the angle of 9√5°. The circle from the theoretical model in virtual form closely marks the angle of 20° at the point where it intersects the square, so he likely decided to create his smaller circle to mark the 9√5° angle as there would not be anything else to indicate it.

The fitting of a mirrored angle for the middle finger of the left hand to point to the pentagram presented a much greater degree of difficulty than the fit of the angle of 9√5° to the middle finger of the right hand. It is immediately obvious that the middle finger of the left hand of the horizontal arm is placed too low to create a line of symmetry for a reflected angle to the horizontal line of the pentagram. Hence Da Vinci must have wanted the reflected angle line to touch a different pentagram line. The only other pentagram line in the vicinity of the left pair of hands is the one which goes to the right foot of the spread-apart pair of legs. Since this line is lower than the horizontal pentagram line, it requires an angle larger than the angle used for the right pair of hands to reach it. It also seemed that Da Vinci wanted to use an angle of very important

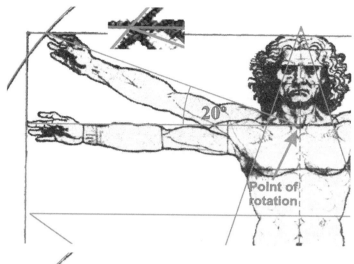

Fig. 2.8a: *A straight line running from the intersection point of the average square with the model circle (see inset) to the point of rotation creates an angle of 20.0040° with the horizontal line from the middle finger of the lower hand. This angle is rounded down to 20° in the image.*

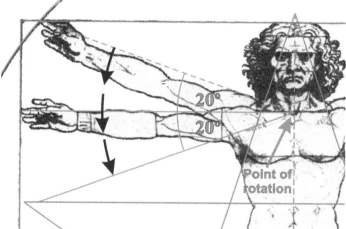

Fig. 2.8b: *If the line from the intersection of the average square with the model circle is rotated counterclockwise about the point of rotation by 40.0080°, it creates a mirror image of the upper angle of 20.0040°. The rotated line touches the horizontal line of the theoretical pentagram. Angles are rounded down to 20° in the image.*

dimension which referred to the sacred geometry of the pentagram. The angle that meets these requirements turns out to be 20.3951°, which has the sacred geometry value of 33Φ°. The number 33 is a very important number in Freemasonry, and Da Vinci was thought by many to have been a Freemason. The capital letter Φ has the value of 0.6180 which is the inverse of the golden ratio number of 1.6180, a number which appears in several places in the pentagram. The value of Φ itself also appears in the pentagram, being a factor in the base side of a pentagram star point. If the length of the side of a pentagram star point is assigned the value of 1 unit, then the length of the base of the star point will be equal to Φ units.

Because the pentagram line to the right foot is not horizontal, the line of symmetry cannot simply be placed midway between the top line of the

square and the level of the end of the reflected line. If Da Vinci used the intersection point of his average square and his average circle to create an angle of 33Φ° with a line of symmetry, the reflected line would be too short to reach the pentagram line to the right foot. The same problem occurs if Da Vinci used the intersection point of his average square and the circle of the theoretical model. Hence, to get a line that was long enough, Da Vinci was forced to alter the top side of his square, drawing it well below the average square in the region where his average circle intersects with his average square (Fig. 2.9). Even this correction was not enough. He was forced to expand the radius of his average circle to the radius of the model circle in order to obtain the right length for the line which was to be reflected. The difficulty in achieving these corrections is evident in his drawing of the middle finger of the upper left hand. The lowering of the top line of the square was not done smoothly. Instead, the square makes a small step downwards between the upper edge of the finger and its tip. Da Vinci even lengthened the tip of the middle finger so that it went slightly beyond the square (Fig. 2.9). The correct line (straight blue line in Fig. 2.10) required for making an angle of 33Φ° with the line of symmetry touches the line of the circle for the theoretical model at approximately the level of Da Vinci's modified square. Indeed, the place where the straight blue line touches the theoretical model circle is the only location where Da Vinci's circle expands to exactly coincide with the model circle. This

Fig. 2.9: *Magnification of the middle finger of the left hand reveals that the finger goes beyond Da Vinci's square. Note that Da Vinci's circle (wide black line) in this region is larger than the average Da Vinci circle (green circle line). The lower part of the finger reaches the expanded circle fitting the theoretical model circle (blue circle line). Note how Da Vinci's square in this region is well below the green line fitting the average Da Vinci square. The square also drops down a small step at the region of the middle finger's tip.*

Fig. 2.10: *The blue line making an angle of 33Φ° with the line of symmetry touches the blue circle for the theoretical model at approximately the level of Da Vinci's altered top line of the square. Note how Da Vinci enlarged his circle to fit the model circle at this point. He restarts his circle line with a smaller radius at the bottom edge of the fingertip.*

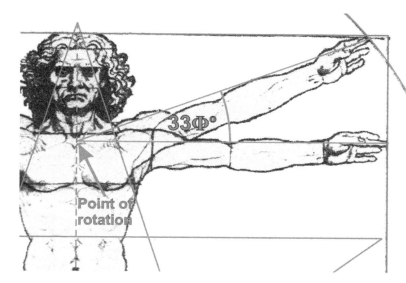

Fig. 2.11a: *This figure shows a straight line running to the point of rotation from the intersection of Da Vinci's modified square with the theoretical model circle. It creates an angle of 33Φ° with the horizontal line from the middle finger of the lower left hand.*

expanded circle line continues in the clockwise direction a small amount beyond his dark line for the square and then terminates. He then restarts his circle line with another line having a smaller radius which comes off of the lower side of the finger tip, i.e., the lower part of the tip of the finger actually protrudes into the width of the restarted line (Fig. 2.10).

The line of symmetry goes from the tip of the middle finger of the hand of the left horizontal arm to the body midline where it forms a point of rotation (Fig. 2.11a). The line from the intersection of the model circle with the altered Da Vinci square (Fig. 2.10) to the point of rotation makes an angle of 33Φ° with the line of symmetry. If this line is rotated by 33Φ° in the clockwise direction about the point of rotation, it lines up with the line of symmetry. Then if it is rotated a further 33Φ°, the distal end of the line touches the pentagram line going to the right foot of the spread-apart pair of feet (Fig. 2.11b). No other line making an angle of 33Φ° with the line of symmetry can do this, regardless of whether the line is made shorter or longer in combination with the line of symmetry being raised or lowered.

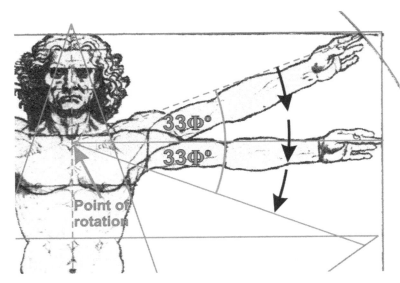

Fig. 2.11b: *If the line from the middle finger of the upper left hand is rotated clockwise about the point of rotation by 66Φ°, it creates a mirror image of the upper angle of 33Φ°. The distal end of the rotated line touches the pentagram line going to the right foot.*

In summary, it appears that Da Vinci followed the theoretical model presented in Chapter 1 for the construction of the Vitruvian Man. He knew about the theoretical circle since he expanded his circle to the exact radius of the theoretical model circle for the middle finger of the hand of the left upper arm. He constructed his slightly smaller circle in order to fit the angle of 9√5° for the middle finger of the hand of the right upper arm. He created lines of symmetry by extending hidden lines horizontally from the tips of the middle fingers of the hands of the lower pair of arms to the midline where they formed points of rotation at the midline. A 9√5° angle on the right side of the body was created by running a hidden line from the intersection of Da Vinci's square with his circle to the point of rotation. This line reflects across the line of symmetry to touch the horizontal line of the hidden pentagram. A similar line on the right side of the body whose upper end touches the square at the virtual intersection of the theoretical circle rather than Da Vinci's circle makes an angle of 20.0040° with the line of symmetry. It reflects across the line of symmetry to also touch the horizontal line of the hidden pentagram. The angle of 20.0040° can be rounded to 20° without a significant loss in accuracy. There is nothing to indicate that Da Vinci actually intended the angle of 20° but the sacred geometry reflected in the number 20 would suggest that he would have wanted this angle in virtual form, particularly since he knew the size of the model radius. On the left side of the Vitruvian Man, Da Vinci lowered the upper side of the square and expanded his circle to the radius of the theoretical circle. An angle of 33Φ° with the hidden line of symmetry was created by running a hidden line to the point of rotation from the

intersection of Da Vinci's modified square with the theoretical circle. This line reflects across the line of symmetry to touch the hidden pentagram line leading to the right foot of the spread-apart pair of legs.

The size and position of the hidden pentagram corresponds exactly with the theoretical pentagram constructed in this chapter. The length of each of the pentagram lines is equal to the model circle radius multiplied by the golden ratio of 1.6180. Hence, Da Vinci used the radius of the model circle for the construction of the hidden pentagram rather than the radius of his smaller circle. This shows beyond a reasonable doubt that Da Vinci knew the correct radius of the theoretical model. A pentagram created from the radius size of the smaller circle would have resulted in a smaller pentagram that would not fit the angle sizes of the reflected arms. Da Vinci would have had to choose different angle sizes which do not relate to the sacred geometry of the pentagram. Thus the square, the base of the equilateral triangle, and the hidden pentagram of the Vitruvian man are all in terms of the radius length of the model circle, and this model almost certainly was the basis for Da Vinci's Vitruvian man drawing even though he drew a slightly smaller circle size than the model circle.

From all of this it is now obvious that the Vitruvian Man was intended by Da Vinci to include the pentagram as well as the circle and the square. As is found in Agrippa's drawing, the center of the pentagram marks the location of the male genitalia, symbolizing fertility and creation. The pentagram was considered by the Catholic Church to be a heretical occult symbol during Da Vinci's time, and this may have been the reason why he kept it hidden. He was well known for using codes and encryption, and only wanted a select group of people, such as members of a secret society, to understand his messages. Hence, the Vitruvian Man was an ingenious way of sending the pentagram message without the general public being able to decipher it. Everyone got side-tracked with his fit of the human body to a square and a circle, and to his demonstration of other body proportions.

While I am not the first to suggest that a pentagram can be fit to the Vitruvian Man, I believe that this is the first time that anyone has shown that Da Vinci truly intended his drawing to be code for this powerful symbol. Attempts by others to fit a pentagram to the Vitruvian Man were generally done to demonstrate that the human body can be used to represent the 5 elements (air, water, fire, earth and spirit)[1] or that the body is proportioned according to the golden ratio,[2] but they give no evidence that Da Vinci actually intended this. None of these approaches give the correct pentagram and most often they proportion the overlaid pentagram to fit within the circle, thus enclosing the head in the upper star point and making the 2 lowest star points positioned too far apart to fit the pair of legs which are spread out.

Fit of the "Equilateral" Triangle

Since Da Vinci used the radius of the theoretical model circle rather than the radius of his circle for the construction of the hidden pentagram, he had to use the radius of the theoretical model circle for the base of the equilateral triangle. This is because the 2 lower star points of the pentagram are at the same locations as the 2 base vertices of the equilateral triangle. As well, they sit on the theoretical circle rather than on Da Vinci's circle which is about 0.034 mm smaller than the model circle at the location of the base vertices.

It therefore turns out that Da Vinci's assertion that "If you open your legs so much as to decrease your height 1/14 and spread and raise your arms till your middle fingers touch the level of the top of your head you must know that the centre of the outspread limbs will be in the navel and the space between the legs will be an equilateral triangle." is not correct. First of all, the triangle would not quite be equilateral since Da Vinci would have had to use his circle's smaller radius (lengthened by 0.034 mm to reach the model circle) rather than the theoretical circle radius for the 2 upper sides of the triangle. The centre of his circle is about 0.256 mm below the centre of the theoretical model circle. This makes the sides of the equilateral triangle from the navel about 0.221 mm shorter than the base side of the triangle. Instead of the triangle having 60° angles, the angle at the navel would be 60.133° and the 2 angles at the base would be 59.933°. Secondly, the height of the man is reduced by 1/12.26 rather than 1/14 when the legs are spread apart to fit the equilateral triangle. It is curious that Da Vinci would have made such a substantial error in height reduction. It suggests that he did not make a precise mathematical calculation but took a rough measurement from his male model instead.

References

1. *Byzant Symbols: The Pentagram.*
 http://www.byzant.com/mystical/symbols/Pentagram.aspx

2. *La Signora Eugenia e il passero solitario.* Cascina Eugenia 1641 srl Società Agricola, viale Azari 72, 28922 Verbania (VB).
 https://www.lasignoraeugeniaeilpasserosolitario.com/8-luomo-di-vitruvio-e-la-proporzione-aurea/

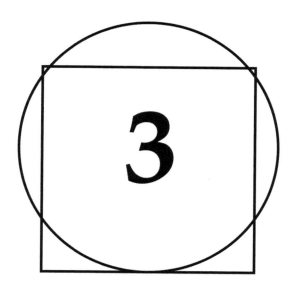

Fit to a Serpent God

I thought that by now I had exhausted the secrets of the Vitruvian Man. But there was one more thing that bothered me. I noticed that for some strange reason, Da Vinci chose to draw several features of the human figure asymmetrically about the body midline. In Fig. 3.1, I drew in the vertical midline of the square assuming it to coincide with the midline of the body. If you look carefully at the figure, you will notice that the man's nose, mouth, and chin are displaced to the right side of the body's vertical midline (inset top left) while the hairline, forehead and eyes are very close to being centred. The left breast is displaced laterally to the left side, and the right hip is much larger than the left hip causing it to extend outwards more to the right. The penis is displaced to the left of the man's body midline (inset middle right). If we look at the right upright leg we see an anatomical impossibility. The right knee is pointed inwards and the lower leg is curved outwards. For this to be possible the leg would have to be broken below the knee, allowing the upper leg to twist inwards and the lower leg to point straight forwards. The lower right leg also appears to have suffered from rickets. This part of the leg is bowed outwards while just above the ankle of the right foot, the outside edge of the leg is markedly indented. If an outline of the spread-apart right leg is superimposed on the upright right leg (see inset bottom left in Fig. 3.1) it can be seen that this version of the leg is straighter than the upright leg.

Was this simply artistic license, or was his model physically abnormal?

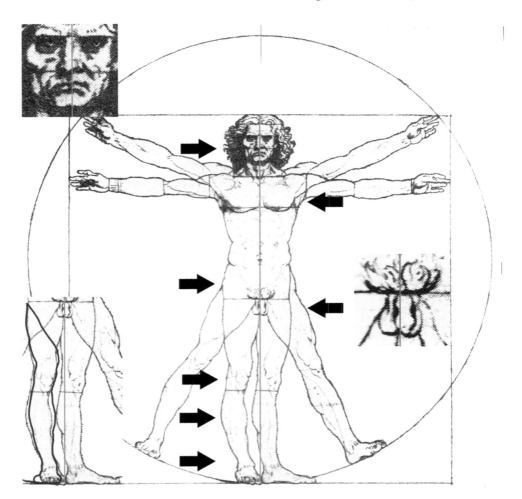

Fig. 3.1: *Deviations from symmetry about the vertical midline of the Vitruvian Man. The right side of the face (inset upper left) and the right hip are displaced laterally to the man's right. The left breast and the penis (inset middle right) are displaced laterally to the left. The knee of the right upright leg is pointed inwards toward the midline. The lower right leg is curved outwards to the man's right. The right leg just above the ankle has a marked indent on the outer side which is not present on the spread-apart right leg. An outline of the spread-apart right leg is shown superimposed on the upright leg in the inset at bottom left. It is straighter than the upright right leg.*

These do not seem to be adequate explanations since, as has been shown with the pentagram, Da Vinci was known to use deception in his drawings. But what could he possibly be focusing on here? At first I thought of the possibility of a serpent twisting back and forth about the midline, but the displacements seemed too small for that so I temporarily abandoned my attempts to find an answer. I came back to this idea a few

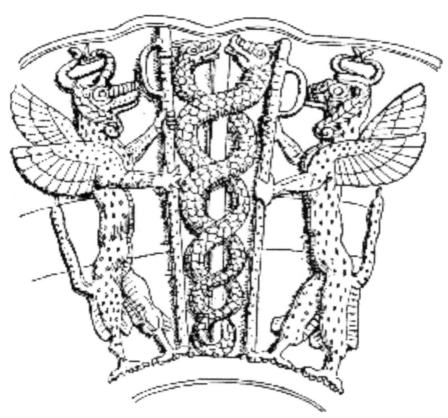

Fig. 3.2: *Ancient Sumerian image of 2 coiled serpents about a rod, the oldest known image of this kind (more than 4000 years old). The serpents intersect each other 7 times if you include the position of their heads even though they don't quite cross over each other. On either side of the serpents are 2 swords held by 2 gryphons. The serpent head and gryphon on the left appear to be female while the serpent head and gryphon on the right appear to be male. The serpent pair was worshipped as a deity known as Ningishzida, associated with both fertility and healing. Wikimedia Commons.*

weeks later, and experimented with several ancient drawings of serpents. Nothing seemed appropriate until I came across a Sumerian image of 2 serpents entwined around a rod (Fig. 3.2). It is the oldest known image of 2 serpents entwined in this way. The serpent pair was known as Ningishzida, a deity associated with fertility and healing. I made a tracing of the serpents in the image and proportioned it to fit the height of the Vitruvian Man human figure (see Fig. 3.3). The result is very impressive. The upper opening between the 2 serpents surrounds the man's head. The navel is located at the 5th intersection from the bottom of the 2 snakes. The center of the pentagram and the genitalia fit nicely inside the 4th opening

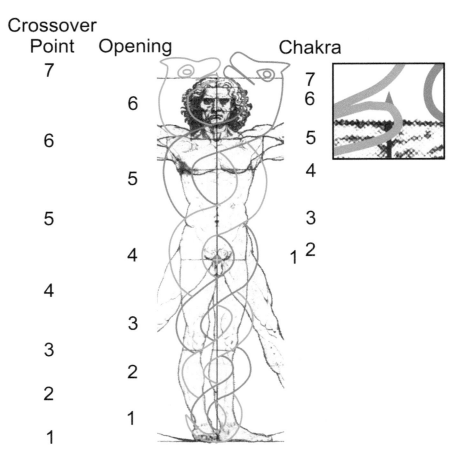

Fig. 3.3: *Overlay of the Ningishzida serpents onto the Vitruvian Man. The serpents were centered on the man's midline and sized to approximate his height. The serpents cross over 7 times if you include the position of their heads. This creates 6 openings between them. The positions of the 7 yogic chakras are approximated in the column to the right. The lateral displacements of the nose, mouth, chin, breast and hip from the midline follow the course of the female serpent (in blue) while the penis is displaced towards the male serpent (in red). The man's upper right leg twists inward and the lower right leg bows outwards to correspond to the path taken by the female serpent. The indent above the right ankle points to the female serpent. The tip of the pentagram's upper star point forms a tooth in the lower jaw of the female serpent (see magnified inset top right). Vitruvian Man photo modified from McMurrich.*

from the bottom. This was enough to make me examine everything in more detail.

The first thing that I noticed was that all of Da Vinci's displacements

from the vertical center line coincide with the locations of the openings between the 2 snakes. Thus the penis and larger right hip are located in the 4th opening from the bottom, the left chest is located in the 5th opening and the chin, mouth and nose are located in the 6th opening. Then I looked more closely at the right leg. It twists inward just above the knee at the level of the 3rd opening between the snakes. Below the knee, it bows markedly outward at the level of the 2nd opening between the snakes. The indent on the lateral side of the right leg just above the ankle bone corresponds to the 1st opening. So here we have all 6 of the openings between the snakes lined up perfectly with distortions in anatomy.

Next, I examined the intersection points of the snakes. If we consider the serpent's heads to form an intersection point even though they don't quite cross, the top 3 intersection points correspond to 3 body parts that center on the midline, namely the navel, the base of the throat and the part in the man's hair.

What about the pentagram? Does it interact with the serpents in any meaningful way? It would seem so since the center of the pentagram lies in the middle of the 4th opening between the snakes, and the tip of the pentagram's upper star point is located at the level of the heads of the snakes. Let's look at that last item more closely. I enlarged that area in Fig. 3.3 so that it could be seen more clearly (see insert top right). The tip of the pentagram star point looks like it creates a tooth in the lower jaw of the blue-coloured snake!

All of these alignments suggest that I have stumbled onto the answer to Da Vinci's off-center distortions. But what was his purpose? The double serpent was used to represent the deity Ningishzida in ancient Sumer more than 4000 years ago. Although generally considered to be male, the deity may have actually been female since it represented fertility and also NIN is usually used as a prefix for a goddess. An extremely good answer to this puzzle was found when my friend George Neville examined the picture more closely. He noted that the heads of the snakes were different, and that one appeared to be female and the other male. Of course! The dual serpent deity contains both female and male principles. The 2 gryphons also appear to be a male and a female. Thus the female gryphon and female snake head are on the man's right and the male gryphon and male snake head are on the man's left. So here we have a deity that incorporates both genders, a concept quite different than many of the world religions of today which consider God as male, and some ancient religions which considered the principle Deity to be female.

If we examine the Ningishzida image in Fig. 3.2 further, we see that there is a rod in the center which the serpents wrap themselves around.

Also the gryphons are holding what appear to be swords which contain the serpents on either side. If we count the number of times the serpents cross over each other we find that this is done 7 times (if we include the heads which don't quite intersect). For those of you who have studied Yoga and Eastern religions, this should start to look very familiar. Here we have what seems to be an obvious representation of the Kundalini Energy which is considered to be a spiritual energy, coiled like a serpent, which lies dormant in the sacrum until it is raised by meditation or yogic awakening. The Kundalini Energy then comes up through a central energy channel (represented by the central rod) and activates the various energy centers or chakras of our spiritual body, ultimately penetrating the crown chakra at the top of the head and forming a spontaneous union with the Universal Divine Energy. The number of chakras is most often considered to be 7, the same as the number of intersections of the serpents in the Sumerian figure. On either side of the central channel are 2 other major energy channels or nadis (the swords to the sides of the serpents in the Sumerian image) which represent, among other things, the past (channel on the left side of the body) and the future (channel on the right side of the body). The central channel or nadi represents the present moment.

The first 2 chakras in the configuration of 7 in the yogic system are located within the 4th opening between the serpents in Fig. 3.3. The other 5 chakras are roughly coincident with the remaining intersections and openings in the upwards direction. But if Da Vinci actually wanted to use the serpents to point out the chakras, why would he position 4 of the serpent intersections and 3 of the serpent openings below all of the yogic chakras? I also tried to fit a smaller version of the entwined serpents between the head and the base of the genitals of the human figure, but the correspondence of the serpent intersections and openings to the positions of the chakras did not match up consistently. From all of this, it would seem that Da Vinci's primary purpose was not to highlight the chakras, and if not the chakras, then probably not the Kundalini Energy either.

Like the pentagram, the dual serpent is centered close to the genitalia. That is pretty strong evidence that one of the messages that Da Vinci was focusing on is the fertility aspect of Ningishzida which this deity is known for. Another more sinister message might have been intended by the tip of the upper star point forming a tooth in the mouth of the female snake. Was this to turn the pentagram into a venomous symbol? The navel, the center of the circle which fits the Vitruvian Man, is located at the 5th serpent crossover point where the female serpent is in front. This would draw attention to the fact that the navel is the remnant of the umbilical cord connection to the mother. Now let's look at all those off-center distortions again. The nose, mouth and chin are off-center to the

man's right in the direction of the female snake in the 6th opening between the serpents. The chest is off-center to the man's left, once again in the direction of the female snake in the 5th opening. The right hip extends laterally much more than the left hip in the 4th opening thus aligning another displacement with the female serpent. Looking at the man's right leg, we see that the inward twisting of the leg above the knee is in the direction of the female snake in the 3rd opening. The outward bowing of the leg below the knee also is in the direction of the female snake in the 2nd opening. The indent in the lateral side of the right leg, just above the ankle, points to the female serpent in the 1st opening. So all 6 of the regions of the off-center displacements and other distortions follow the female snake and they all correspond to the openings between the serpents. Hence, from all of this, I would surmise that Da Vinci was using the serpent image primarily to symbolize female fertility.

But what about the placement of the penis to the man's left? It is displaced in the direction of the male snake in the 4th opening. This may be simply acknowledging the obvious, that this piece of anatomy comes with being male. But if the serpents are intended to represent fertility, should it not be displaced in the direction of the female serpent? After all, the role of a penis in reproduction is to inseminate the female. But let's not forget that Da Vinci is heavily devoted to code and symbolism. I think that there is a deeper meaning here. I would suggest that there is a good possibility that he is alluding to the fact that he is gay - in an era when it would be extremely dangerous to openly proclaim it. His homosexuality, while not established with certainty, is strongly thought to be the case by many people.

So Da Vinci's Vitruvian Man has 3 symbols of fertility - a square which centers at the base of the penis, a hidden pentagram which also centres at the base of the penis, and a hidden female-male fertility god which Da Vinci uses to focus on the female rather than the male. Underlying all of this is a demonstration of how the shape of the human body conforms to sacred geometry. We are now going to examine how this artistic work is very likely related to the planet Mars.

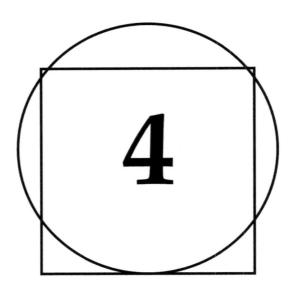

The Link to Mars

W here did Da Vinci get his geometric model of the Vitruvian Man? The model that I am referring to is the theoretical model created in Chapter 1 with the addition of the pentagram created in Chapter 2. This model perfectly explains the geometry of the Vitruvian Man drawing with the exception of the slight modifications that Da Vinci made to the circle and to the upper side of the square near the left hand. These modifications permitted the middle fingers of the upper pair of arms to assume different positions than they would have taken with the theoretical model. Rather than touch the intersection points of the upper line of the square with the theoretical circle, the modified positions allowed the middle fingers to create specific angles which were reflected across lines of symmetry to point out 2 of the lines of the hidden pentagram. The lines of symmetry themselves were aligned with the middle fingers of the horizontal arms, and these fingers were positioned so that the lines of symmetry would be at the correct height. The magnitudes of the specific angles were values to be found in sacred geometry, particularly the kind of sacred geometry which I found to be prevalent on the surface of the planet Mars.[1,2,3] This is one indication that Da Vinci knew something about the planet Mars that the rest of humanity is totally ignorant of. Another indication is that a virtual form of the Vitruvian Man has existed on the surface of Mars for eons before Da Vinci ever made his drawing.[1]

Leonardo is well known for his engineering drawings of inventions which were far beyond his era such as a helicopter, a parachute, a hang glider, military tanks and cannons. Were these simply inspirations of genius, or did Da Vinci have access to knowledge available only to a select elite who passed it on from ancient sources which were produced by civilizations that were in contact with advanced alien civilizations? The body of knowledge that was in the possession of the ancient Egyptian Mystery Schools is one source that Da Vinci was thought to have had access to, as had Pythagoras, Plato, Aristotle, Copernicus, Kepler and Newton.[4] Another possibility is that Da Vinci had in his possession knowledge brought to Earth from Mars itself, knowledge that was known to the early Greeks. There is evidence of structures on Mars in the form of the Greek symbol for omega and the archaic digamma symbol.[3] Also, the builders of the ancient megalithic sites such as Stonehenge used a standard of measure based on the exact equatorial radius of Mars.[1] How could this be? How could the builders of Stonehenge ever have obtained knowledge of the radius of Mars? How could Greek symbols exist on Mars itself? Mars is supposed to be a totally dead planet that has never hosted life, let alone, intelligent life. At least that is what NASA has drummed into us ever since the Mariner spacecraft sent us images of Mars back in 1965.

In order to understand this chapter and the latter part of this book, you will have to part with your current belief systems about the planet Mars which have been heavily promoted by NASA. This will not be easy for most people because it requires a conceptualization that is totally unfamiliar to all of our past experience. My 3-book series on Mars[1,2,3] has scientifically established that Mars is a very extraordinary planet whose topography has largely been engineered into existence by a highly advanced civilization. It did not arise from the natural processes we are familiar with on the planet Earth. Huge mountains were not the result of volcanic activity and most craters were not formed by impacts from outer space. Even immense features like the Valles Marineris and the Hellas Basin have been artificially constructed.

The 4 Giant Mountains

Although you would expect the 4 giant mountains to have been naturally formed by volcanic activity, I have discovered that they must have been artificially created by an advanced civilization.[1] This is very difficult for most people to accept since we experience volcanos on Earth and therefore assume that the Martian mountains should have arisen by repeated volcanic eruptions. After all, calderas are evident on their

summits, and calderas are formed from volcanic eruptions. However, when these mountains are examined more closely, their artificiality is revealed by the presence of multiple linear edges which can extend for dozens of kilometers and have bearing angles (angles from due north) which are limited to values divisible by 3, and most frequently to values found in sacred geometry such as 36°, 45° and 54°. The 4 giant mountains are also arranged in a pattern which is highly unlikely to have occurred naturally. The 3 Tharsis Montes of Ascraeus Mons, Pavonis Mons and Arsia Mons are arranged in a straight line and are equidistant from one another (Fig. 4.1). Olympus Mons creates what appears to be an isosceles triangle with the other 3 mountains. These mountains have multiple calderas on their peaks. However, the calderas themselves have several linear edges with bearing angles reflecting sacred geometry, so they too must have been artificially created to give the illusion that the mountains are volcanic in origin.

It is difficult to determine the exact intended location of the centres of these mountains since their calderas give confusing information. It was not until I discovered the existence of survey craters[1] that I could confirm the artificiality of the positioning of the mountains by determining the coordinates of their centres with only a very small amount of error. Survey craters are craters which the Martian architects created in order to locate the "centre" of the mountain. The surveying procedure would have had to be done from many kilometers above the surface of the planet. Two or more survey craters exist at a meaningful distance from the "centre" of a mountain, allowing them to mark a unique location which simultaneously satisfies a special distance from each of the survey craters. The distances are measured by rhumb lines rather than great circle lines. A rhumb line is a line which maintains its bearing angle (the angle from due north) over its entire course. Sailors used rhumb lines to maintain course on ocean journeys before the invention of clocks that were accurate enough to enable longitude to be calculated at sea. A great circle is the intersection of the surface of a sphere with a plane passing through its centre. Any great circle divides the surface of the sphere into 2 equal halves. Examples of great circles are the Earth's equator and lines of longitude. A great circle line gives the shortest distance between 2 locations but its bearing angle varies over distance unless it is a section of a line of longitude or of the equator. From my previous work,[1,2,3] I have discovered that the Martian architects used rhumb lines rather than great circle lines in creating geometric shapes such as triangles or squares since bearing angles were an important part of their devotion to sacred geometry. All straight lines drawn on a Mercator projection map are rhumb lines, and all maps used in this book are Mercator projection maps.

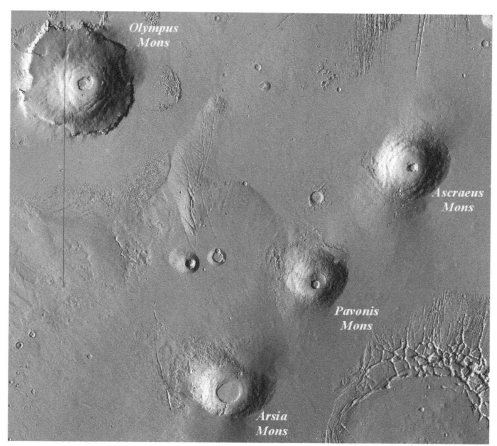

Fig. 4.1: *The 4 giant mountains on Mars appear to form a triangular pattern with Olympus Mons at the apex and the 3 Tharsis Montes forming the base. USGS Astrogeology.*

I call the location which is surveyed from the survey craters the "survey centre" of the mountain. The survey centre can deviate from the physical centre somewhat, and it is used by the Martian architects for a special purpose such as to mark a mountain's position or to mark a prime meridian. For Ascraeus Mons, there are 2 craters whose centres are at a distance of exactly $R/(2\pi)$ km from the survey centre of the mountain (Fig. 4.2, image a). R is the equatorial radius of Mars and it is equal to 3396.19 km. For Pavonis Mons, there are 5 craters which are at a distance of exactly $R/(2\pi)$ km from the survey centre of the mountain and a single crater which is at a distance of $R/(3\sqrt{5})$ km (image b). For the Arsia Mons survey centre, there are 2 craters at a distance of $eR/20$ km (image c). For the survey centre of Olympus Mons there are 2 survey craters which are at a distance of $R/(3e)$ km and another pair at a distance of $R/(2\sqrt{5})$ km (image d).

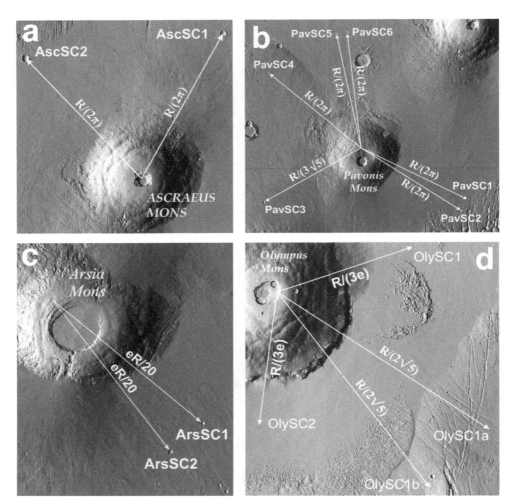

Fig. 4.2: *Survey craters for the 4 giant mountains. Two survey craters for Ascraeus Mons and 5 survey craters for Pavonis Mons are at a distance of R/(2π) km from the survey centres of the respective mountains. A 6th survey crater is at a distance of R/(3√5) km for Pavonis Mons. For Arsia Mons, 2 survey craters are at a distance of eR/20 km. There are 2 survey craters, each at a distance of R/(3e) km, and another 2, each at a distance of R/(2√5) km, from the survey centre of Olympus Mons. USGS Astrogeology.*

When all of the survey centres of the 4 mountains are joined together with rhumb lines, an isosceles triangle is closely approximated which has the remarkable property of the base being equal to the height (Fig. 4.3). Both the base and height have a length equal to $R/\sqrt{5}$ = 1518.822 km with a tiny amount of error. The survey centre of Pavonis Mons is extremely close to the location that bisects the isosceles triangle into 2 right angle triangles. Because the base of the isosceles triangle is equal to its height, each of the 2

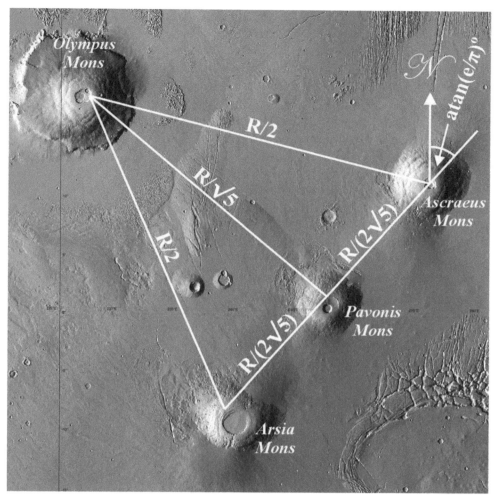

Fig. 4.3: *Fit to the survey centres of the 4 giant mountains reveals an isosceles triangle whose base is equal to its height (R/√5 = 1518.822 km). The value of R is the equatorial radius (= 3396.19 km) of Mars. The isosceles triangle is bisected into 2 right angle triangles at Pavonis Mons, and its base has a bearing angle equal to atan(e/π) = 40.8682 degrees in the clockwise direction. Due to spherical geometry, the distance between Olympus Mons and Ascraeus Mons is about 29.6 km less than R/2 km, and the distance between Olympus Mons and Arsia Mons is about 4.3 km more than R/2 km. USGS Astrogeology.*

right angle triangles created by the line from Pavonis Mons to Olympus Mons is half of a double square (allowing for spherical geometry). A double square is formed by 2 adjacent squares of equal size making a rectangle whose length is twice its width. Assuming that R/√5 km is the intended length of the base and the height, if the triangle is placed on a flat surface, by the Pythagorean theorem it can be calculated that the 2 equal sides of the

isosceles triangle have a length equal to R/2 km. Hence, the distances between the mountains can be expressed as meaningful sacred geometry formulae which are functions of the planetary equatorial radius R. However, since the triangle is on a spherical surface, the 2 upper sides of the isosceles triangle cannot be equal. The side between Olympus Mons and Ascraeus Mons is about 29.6 km less than the value of R/2 km = 1698.095 km. The side between Olympus Mons and Arsia Mons is about 4.3 km more than R/2 km. The lines between Pavonis Mons and the other 3 mountains are almost exactly equal to their sacred geometry formulae. Another very interesting finding is that the base of the isosceles triangle has a clockwise bearing angle of atan(e/π) = 40.8682 degrees with a discrepancy of only about 1 minute of a degree. This is another property of the giant mountain isosceles triangle which provides strong confirmation of the artificiality of the placement of the mountains as indicated by their survey centres.

The bisected isosceles triangle and the half double squares created by the 4 giant mountains are mimicked by the Vitruvian Man. If the top corners of the Vitruvian Man square are joined to the midpoint of the bottom side of the square occurring at the feet of the upright pair of legs, diagonals are created of the 2 double squares which arise when we add in the vertical midline of the square (Fig. 4.4). If an arbitrary value of 2 units is assigned to the side length of the Vitruvian Man square, the diagonals which we created would then be equal to √5 units. If the side length of the square is R/√5 km, the diagonals would be R/2 km. All of this suggests that the 4 giant mountains are intended be a template for the Vitruvian Martian.

References

1. *Intelligent Mars I: Sacred Geometry of the Mountains. Did Da Vinci Know?* Arthur Raymond Beaubien. Epiphi Productions, Ottawa, Ontario, Canada. 2015.

2. *Intelligent Mars II: The Code of the Craters.* Arthur Raymond Beaubien. Epiphi Productions, Ottawa, Ontario, Canada. 2019.

3. *Intelligent Mars III: Aum and the Architect.* Arthur Raymond Beaubien. Epiphi Productions, Ottawa, Ontario, Canada. 2020.

4. *Initiation Process - What is a Mystery School?* Ancient Egypt Mystery Schools. Hosted by Anyextee. April 20, 2015. https://ancientegyptmysteryschools.com/what-is-a-mystery-school-initiation-process/

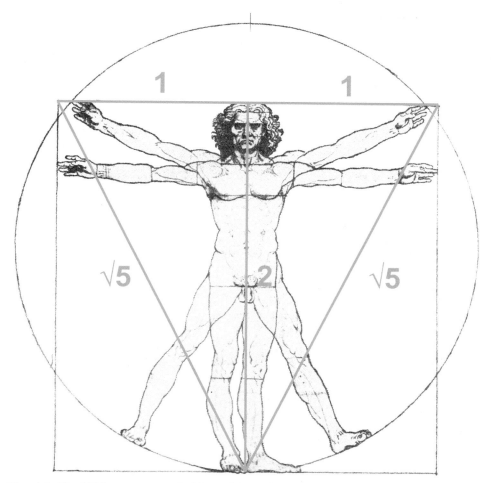

Fig. 4.4: *The hidden presence of a bisected isosceles triangle in the Vitruvian Man formed from the top line of the square as its base and the midline of the square as its bisector. When the side length of the square is assigned a value of 2 arbitrary units, from the Pythagorean theorem it can be calculated that the length of each of the 2 equal sides of the isosceles triangle will be √5 units. The midline of the square divides the square into 2 double squares each having a length of 2 units and a width of 1 unit. The similarity to the pattern created by the 4 giant mountains suggests that the mountains are intended to be a template for the Vitruvian Martian. Vitruvian Man photo modified from McMurrich.*

A Pentagram Pyramid

The idea that the 4 giant mountains of Mars might be a template for the Vitruvian Martian would remain speculation if it were not for the discovery of a very special pyramid in their vicinity. This pyramid is to be found just west of Biblis Tholus which is one of 2 small mountains west of Pavonis Mons and northwest of Arsia Mons. Figure 5.1 shows the position of the pyramid in relationship to the 2 small mountains. The pyramid has the shape of a 5 pointed star which forms a pentagram and hence, I have called it the Pentagram Pyramid. The black horizontal line in the image is the equator which is in close proximity to the Pentagram Pyramid.

If we look at the Pentagram Pyramid at higher magnification (Fig. 5.2), we see that all of its star points show damage except the southwest star point which appears mostly intact. The eastern side of the pyramid shows the most damage. There are 3 large structures at a more northerly latitude than the pyramid. The middle structure has the appearance of a face although the resolution is very low.

So how can we determine whether or not the Pentagram Pyramid is a real pyramid in the shape of a pentagram or simply an oddity of nature? The answer to this question lies in its coordinates, its size and rotation with respect to due north, and in the pyramid's relationship to other topography. To begin with, let's look at the latitude of its centre. The latitude of the centre of the star-shaped object seemed to be slightly less

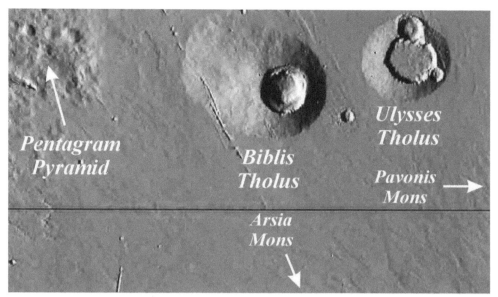

Fig. 5.1: *Map showing the location of the Pentagram Pyramid in relation to Biblis Tholus, Ulysses Tholus and the giant mountains of Pavonis Mons and Arsia Mons. USGS Astrogeology.*

than the value of $\pi°$ N. Any attempt to bring an overlaid pentagram shape further north to an exact $\pi°$ N would position the entire pentagram too far northwards to give a credible fit. I finally hit upon the idea of converting the latitude coordinate from the planetocentric coordinate system to the planetographic coordinate system. This latter system takes the ellipsoidal nature of the planet into account whereas the

Fig. 5.2: *The Pentagram Pyramid at a higher magnification shows considerable damage especially on the east side. The southwest star point seems mostly intact. There are 3 large structures further north of the pyramid. The middle structure appears to be a face. USGS Astrogeology.*

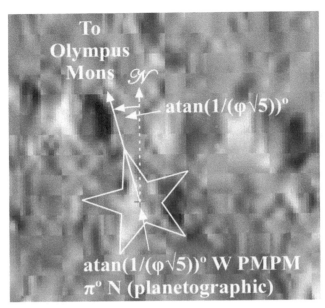

Fig. 5.3: *The star-shaped structure is nicely fit by a pentagram which is rotated counterclockwise by 15.4504° = atan(1/(φ√5))° from having a star point aimed due north. This results in the NW star point being aimed towards the survey centre of Olympus Mons. In symmetry with this, the centre of the pentagram is located atan(1/(φ√5))° west of the PMPM prime meridian which is marked by the survey centre of Pavonis Mons. The Pentagram Pyramid centre is at π° N in planetographic coordinates. USGS Astrogeology.*

planetocentric system, which NASA uses, assumes the planet to be a perfect sphere with a radius equal to its equatorial radius. Suddenly I was very close to a perfect fit! That led me to position the pentagram at exactly $\pi = 3.1416°$ N in planetographic coordinates which was determined to be 3.1046° N in planetocentric coordinates (Fig. 5.3).

After much experimentation I decided to make the diameter of the pentagram equal to exactly 0.5 latitude degrees (planetocentric) since this size gave an excellent fit to the southwest star point which was the most clearly defined one. The size of many objects on Mars such as the diagonal of "square" craters has been shown to be in units of latitude degrees.[1] The size of a latitude degree in the planetocentric system is constant regardless of latitude and is equal to 59.275 km. It is equal to the size of a longitude degree at the equator. Thus the diameter of a circle drawn around the entire Pentagram Pyramid is 29.637 km. This is a truly enormous structure, making the great pyramid of Egypt, which has a side length of 0.230 km, look like a child's toy in comparison. An entire city could be placed inside its perimeter.

I then had to decide on the amount of rotation the pentagram should be given from having a star point aimed due north (Fig. 5.3). Although a range of 12 - 18 degrees of rotation in the counterclockwise direction gave credible fits, I finally settled on the value of atan(1/(φ√5)) = 15.4504° since it was a sacred geometry formula that gave a strong reference to the golden mean $\varphi = 1.6180$ and therefore, the pentagram. This value is virtually indistinguishable from 25Φ = 15.4508° which also refers to the

pentagram since 25 is the square of the number of star points in a pentagram and Φ is the inverse of the golden mean. Surprisingly, the angle of atan(1/(φ√5))° rotation caused the northwestern star point to be pointed almost directly at the survey centre of Olympus Mons. This is the first indication that the Pentagram Pyramid is somehow connected to the construction of a Vitruvian Martian from the 4 giant mountains.

I adjusted the longitude of the rotated Pentagram Pyramid so that the northwestern (NW) star point pointed exactly at the survey centre of Olympus Mons. In this way, the longitude of the centre of the Pentagram Pyramid was set to 231.6302° E. Amazingly, this longitude is only about 1.4 minutes of a degree more than the longitude value of atan(1/(φ√5))° W from the longitude of the Pavonis Mons Prime Meridian. The close symmetry of this longitude with the angle of rotation of the Pentagram Pyramid from having a star point aimed due north could only have come about by careful planning. The Pavonis Mons Prime Meridian (PMPM) is marked by the survey centre for Pavonis Mons and it is one of the ancient prime meridians which I discovered to exist for the planet Mars.[1] The PMPM has a longitude of 247.1047° E. I used the longitude of 231.6302° E for my initial estimate of the centre of the Pentagram Pyramid. A more precise setting of its longitude is discussed in the next chapter.

Besides the fact that the NW star point of the Pentagram Pyramid points to the survey centre of Olympus Mons, another thing that connects the Pentagram Pyramid to the construction of a Vitruvian Martian from the 4 giant mountains is the fact that its northeastern (NE) star point points to a location on the line between Olympus Mons and Pavonis Mons which is very close to where the navel of the Vitruvian Martian should lie. In my earlier book on the mountains of Mars,[2] I found that when I tried to fit a square and a circle to the 4 giant mountains, the proportional relationship between Da Vinci's square and circle from his Vitruvian Man drawing positioned the navel (i.e., the centre of the circle) so that the NE star point of the Pentagram Pyramid pointed directly at it. This strongly suggested that the purpose of the Pentagram Pyramid was to point out both the position of the Vitruvian Martian's navel and the location of the feet of the pair of upright legs which is at the survey centre of Olympus Mons. Hence, the distance between the location of the survey centre of Olympus Mons which is pointed out by the NW star point, and the navel which is pointed out by the NE star point, provides a measure of the radius of the circle which fits the Vitruvian Martian. All of this indicates that the 4 giant mountains were intended to provide a template for a Vitruvian Martian, and it is highly likely that Da Vinci used the Vitruvian Martian as the model for his Vitruvian Man.

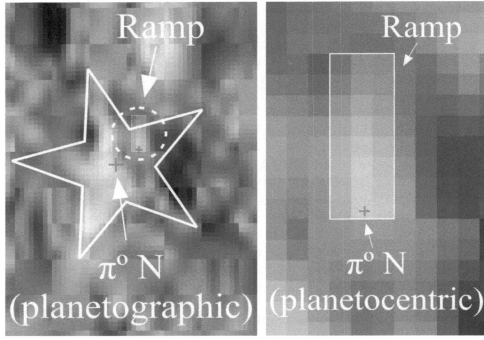

Fig. 5.4: *Left image: a ramp can be seen at the base of the northeast star point of the Pentagram Pyramid (see inside dashed circle). The centre of the Pentagram Pyramid is located at the planetocentric latitude of 3.1046° N which is π° N planetographic. Right image: a magnification of the ramp shows it to be a rectangular structure in which the pixel colour gets brighter gradually from north to south. The brightest pixel is at the southern end of the ramp structure which suggests that it is the highest point. The red cross shows that the latitude of 3.1416° N = π° N planetocentric occurs within this pixel. USGS Astrogeology.*

The Pentagram Pyramid Ramp

There is something else that is remarkable about the Pentagram Pyramid which shows that this is a structure that has been intelligently engineered. At the base of the NE star point there is a light coloured rectangular region that is mostly inside the Pentagram Pyramid, with only its northern part extending outside the pyramid (Fig. 5.4, left image). If we look at the rectangular region under higher magnification (Fig. 5.4, right image), it can be seen that it increases gradually in brightness from north to south. The latitude of π = 3.1416° N in planetocentric coordinates was found to occur at the southern end of the rectangular region. All of this suggests that the rectangular region represents a ramp which travels for about 5.3 km precisely in a north to south direction and probably has a marker of some sort, such as an obelisk, at the latitude of π° N to honour the value of

π. The red cross inside the white rectangle is located at a latitude of exactly π° N in planetocentric coordinates. It is positioned inside the brightest pixel, the pixel which would correspond to the highest point on the ramp-like structure. I located its longitude dimension slightly to the east in this pixel since the eastern column of pixels that compose the ramp are brighter than the western column, suggesting that the ramp extends more into the eastern column than into the western column. A more precise longitude will be established in the next chapter.

Hence, the Pentagram Pyramid honours the value of π in a big way with its centre being located at π° N in planetographic coordinates and the high point of an embedded large ramp being located at π° N in planetocentric coordinates. It has its NW star point closely aimed at the survey centre of Olympus Mons and its NE star point closely aimed at the navel of what is most likely the virtual presence of a drawing of a Vitruvian Martian. The survey centre of Olympus Mons would be located at the feet of the upright pair of legs, and the distance between the survey centre of Olympus Mons and the navel would provide a measure of the radius of the circle which fits the Vitruvian Martian. The sophistication of the design of the Pentagram Pyramid and the positioning of the 4 giant mountains could only have come about by intelligent engineering. This lends huge supporting evidence for the reality of the existence of the Pentagram Pyramid and a Vitruvian Martian which likely was the inspiration for Da Vinci's Vitruvian Man.

References

1. *Intelligent Mars II: The Code of the Craters.* Arthur Raymond Beaubien. Epiphi Productions, Ottawa, Ontario, Canada. 2019.

2. *Intelligent Mars I: Sacred Geometry of the Mountains. Did Da Vinci Know?* Arthur Raymond Beaubien. Epiphi Productions, Ottawa, Ontario, Canada. 2015.

Figuring Out the Vitruvian Martian

I n my original fitting of the Vitruvian Martian presented in *Intelligent Mars I: Sacred Geometry of the Mountains. Did Da Vinci Know?*,[1] I used the measurements which I made from Da Vinci's drawing. These measurements were compatible with the NW star point of the Pentagram Pyramid pointing to the bottom pair of feet of the Vitruvian Martian located near the survey centre of Olympus Mons, and to the NE star point pointing to the navel of the Vitruvian Martian. The reason that the NE star point was able to point to the navel was that I used Da Vinci's circle instead of the circle from the model presented in Chapter 1 since the new model had not been developed yet. This caused the centre of the circle which represents the navel to be lower than the centre of my new model circle. I also measured the square size (side length = 181.383 mm to be a bit larger than what was estimated from the new model (side length = 181.126 mm). This caused the circle radius to be slightly smaller in proportion to the square and thus was another factor in pushing the centre of the circle (the navel position) lower in relation to the position of the top of the head than would be achieved with the new model.

I will now fit the new model of the Vitruvian Man to the Martian giant mountains, integrating it with the Pentagram Pyramid which was presented in the previous chapter. As was done in *Intelligent Mars I*,[1] I will call the full image the *Vitruvian Martian* to distinguish it from Da Vinci's Vitruvian Man. There are a few knowns which can be obtained

from very plausible assumptions:

(1) The base of the bisected isosceles triangle fitting the mountains (Ch. 4, Fig. 4.3) forms the top line of the square and has a length of $R/\sqrt{5}$ = 1518.822 km. The line which bisects the isosceles triangle forms the midline of the square and is equal to the length of the base.

(2) The top line of the square has a clockwise bearing angle of $\operatorname{atan}(e/\pi)°$ = 40.8682° from due north. The midline of the square has a counter-clockwise bearing angle of $\operatorname{atan}(\pi/e)°$ = 49.1318° from due north.

(3) The top line of the square is centred at a latitude of $\varphi°$ N (planetographic) close to the survey centre for Pavonis Mons, and the bottom line of the square is centred close to the survey centre for Olympus Mons.

(4) The top corners of the square are located close to the survey centres for Ascraeus Mons and Arsia Mons.

We have seen in Chapter 4 how the survey centres of Ascraeus Mons, Pavonis Mons, Arsia Mons and Olympus Mons are nicely fit by a bisected isosceles triangle (Fig. 4.3). However, there is some error associated with the estimation of each survey centre from its survey craters. The question arises as to how the exact placement of the square of the new model created from assumptions #1 to #4 above can be found.

The Aum Crater

In order to get a good fit of the new model of the Vitruvian Martian, we cannot just start with data obtained by measuring out the survey centres of the 4 giant mountains or the Pentagram Pyramid itself. Surprisingly, I have found that we must turn to a crater approximately 70 km in diameter which is located more than 2300 km southwest of Olympus Mons. This crater does not have an official name. In *Intelligent Mars III*,[2] after a very extensive analysis, I have discovered that the crater represents the concept of Aum which is the primordial sound which many religions believe gave rise to the universe. Hence, I gave it the name Aum Crater. It can be seen in Fig. 6.1 that the Aum Crater has an overall square shape and that there is a second crater which lies within the eastern half of the larger crater. It was found that a fundamental square with a diagonal size of 1° (i.e., 1 latitude degree) could be fit within the larger crater, and that a fundamental octagon with a radius size of 0.25° could be fit within the smaller crater. The fundamental octagon plays a key role in fitting the Vitruvian Martian to the mountain architecture so I will now focus on it rather than the fundamental square. The fundamental octagon is shown in Fig. 6.2. The rationale for selecting

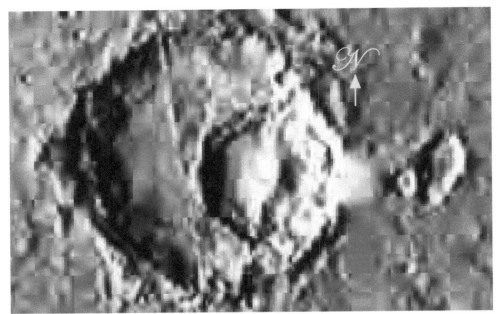

Fig. 6.1: *The Aum Crater has an overall square-like appearance with its sides tilted at 45° with regard to due north. Within the east side of the Aum Crater there is a second large crater which has linear sides, and is best fit with an octagon. USGS Astrogeology.*

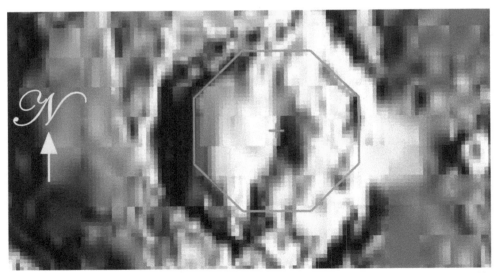

Fig. 6.2: *The fundamental octagon centred at the red cross (208.1047° E 16.6254° S). Red lines superimposed on the blue octagon outline demarcate regions of alignment with structures inside the multi-sided crater. Note how well the octagon follows the linear interface between black and green/grey-green areas on the west and northwest sides. The east side follows the linear edge of a dark grey area and the northeast side, the linear edge of a light grey area. See how well the angles are fit in these areas. USGS Astrogeology.*

this octagon and its positioning is well described in *Intelligent Mars III*.[2]

The Aum Crater was found to represent the concept of Aum by depicting the spreading out of multiple concentric squares and multiple concentric octagons. The sizes of the larger squares are harmonics of the size of a fundamental square, and the sizes of the larger octagons are harmonics of the size of a fundamental octagon. In music, harmonics are simply integer multiples of a fundamental frequency. If a piano is tuned harmonically (rather than tuned according to equal temperament as is the usual case today), the notes above a certain note used as a fundamental frequency such as middle C are at harmonic intervals above it. Suppose we tune middle C on such a piano to 256 cycles per second (Hz). The second harmonic would be 2 x 256 = 512 Hz and would be the C note one octave higher. It can be brought back into the first octave by dividing by 2 which would then return it to the fundamental frequency of 256 Hz. The third harmonic would be 3 x 256 = 768 Hz and would be the G key in the second octave. To bring this note into the first octave, we would have to divide it by 2, leaving us with a frequency of 384 Hz which would be the G note in the first octave. The fourth harmonic would be 4 x 256 = 1024 Hz which would be C in the third octave. It can be brought back into the first octave by dividing by 4, leaving us with the fundamental frequency of 256 Hz. The fifth harmonic would be 5 x 256 = 1280 Hz which would be the E note in the third octave. To bring it into the second octave, we would have to divide by 2, giving us a frequency of 640 Hz which would be the E note in the second octave. To bring it into the first octave we would divide the 1280 Hz frequency by 4 to get 320 Hz which would be the E note in the first octave. The interval ratios we have created so far are 1:1 (fundamental), 2:1, 2:2, 3:1, 3:2, 4:1 4:4, 5:1, 5:2 and 5:4. Thus the numerator of a harmonic interval ratio is simply a pure integer that multiplies the fundamental frequency to create a harmonic frequency. The denominator is an integer that has to be a power of 2, and it is used to bring the harmonic frequency into the range of the desired octave.

If we assume that the radius of an octagon is an analogue of sound frequency, then the radius of the fundamental octagon in Fig. 6.2 represents the fundamental frequency, and the radii of all expanded harmonically related octagons represent harmonic frequency intervals above this. For an expanded octagon having a harmonic relationship to the fundamental octagon, the ratio of the radius of the expanded octagon to the radius of the fundamental octagon would be the interval ratio between the 2 sizes of octagon. As with sound, this interval ratio can be expressed as an integer divided by a power of 2. The divisor is used to bring the numerator into the desired octave of size values rather than frequency values. For example, an octagon having a radius size of 0.8125° compared to the radius size of 0.25° for the fundamental octagon creates a

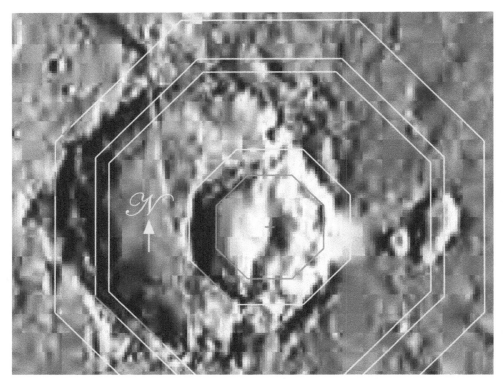

Fig. 6.3: *Octagons at harmonic intervals above the fundamental octagon. All of the expanded octagons align with linear segments of the perimeters of the internal crater and the Aum crater. Short red lines mark alignments. Interval ratios from smallest to largest octagon are: (1) 1:1 [fundamental] (2) 3:2 (3) 3:1 (4) 13:4 and (5) 4:1. USGS Astrogeology.*

ratio of $0.8125/0.25 = 3.25$. The smallest number which is a power of 2 that can convert the number 3.25 into an integer by a process of multiplication is the number 4. By multiplying 3.25 by 4 we obtain the integer 13. Thus the number 3.25 can be expressed as an interval ratio of the integers 13 and 4, i.e., 13:4. The sizes of interval ratios, when worked out to single rational numbers, can be grouped into octaves. The first octave would range from 1 to <2, the second octave from 2 to <4, the third octave from 4 to <8, etc. Since the interval ratio of 13:4 works out to 3.25, the octagon having a radius size of 0.8125° lies in the second octave of sizes.

The expanded octagons are virtual rather than physically marked out on the Martian landscape. Their presence is established by their alignment to linear sites in the landscape. Fig. 6.3 shows 4 such octagons, one of which aligns to a linear segment of the internal crater's perimeter, and the other 3 to linear segments of the Aum Crater's perimeter. Each of the expanded octagons creates a harmonic interval ratio with the fundamental octagon. From smallest to largest, the harmonic interval ratios are 1:1 (the

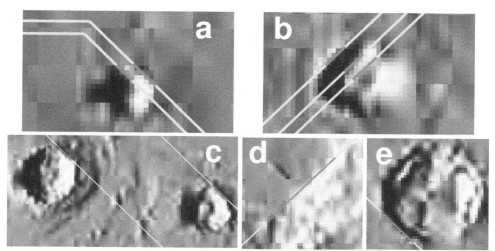

Fig. 6.4: *Octagons at harmonic intervals above the fundamental octagon fitting linear structures well beyond the Aum Crater. Interval ratios are: (a) left to right, 8:1 and 65:8 (b) right to left, 10:1, 81:8 and 165:16 (c) left to right, 13:1 and 15:1 (d) 18:1 and (e) 64:1. USGS Astrogeology.*

fundamental octagon), 3:2, 3:1, 13:4 and 4:1. The interval ratio of 3:2 is in the first octave of sizes but the ratios of 3:1 and 13:4 lie in the second octave, and the ratio of 4:1 is the start of the third octave.

Expanded octagons which not only fit linear structures on the planetary surface but also create interval ratios which are harmonics of the fundamental octagon are found well beyond the perimeter of the Aum Crater. Fig. 6.4 shows 9 such octagons. In Figure 6.4a, 2 octagons align to an arrow-shaped crater pointing due east. The smaller octagon has an interval ratio of 8:1 and aligns to the linear bottom edge of the crater wall. The larger octagon has an interval ratio of 65:8 and aligns to the part of the crater perimeter which forms the northern edge of the arrow. Both of these interval ratios lie in the fourth octave of sizes. Image b shows 3 octagons in the fourth octave which align to an arrow-shaped crater pointing due west. The smallest octagon (right) has an interval ratio of 10:1 and aligns to a linear dark shape in the central region of the crater. The next octagon has an interval ratio of 81:8 and aligns to the northern edge of a white arrow shape interior to the crater. The largest octagon has an interval ratio of 165:16 and aligns to the northern edge of an arrow shape created by the perimeter of the crater. In image c, the smaller octagon (left) has an interval ratio of 13:1 and it aligns to the linear northeast side of a crater. The larger octagon has an interval ratio of 15:1 and it aligns to the northern side of the arrowhead of an arrow-shaped crater which has a notch in the arrow's tip. Both of these octagons

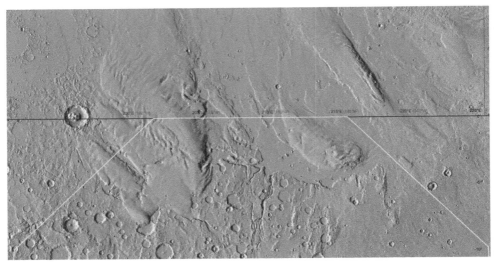

Fig. 6.5: *Octagon with an interval ratio of 72:1 and a radius size of 18 latitude degrees. The north side of the octagon passes through the equator and likely depicts the planet having been created from the Aum sound. USGS Astrogeology.*

have interval ratios that reside in the fourth octave of octagon sizes. In image d we see the northwest side of a fifth octave octagon having an interval ratio of 18:1 which aligns to the bottom linear edge of the wall of the large Burton Crater. In image e, the northeast side of a seventh octave octagon with an interval ratio of 64:1 aligns with the southwest linear side of a large crater. This octagon has a radius size of 948 km.

Next I am going to show you a very special octagon that resides in the seventh octave of octagon sizes (Fig. 6.5). It turns out that the north side (latitude = 0.0044° N) of this octagon aligns with the Martian equator almost perfectly, being only 0.263 km north of the equator. This octagon therefore provides overwhelming evidence that one of the things that the Aum sound emanating in the form of octagons from the Aum Crater was meant to depict was the creation of the entire planet itself! The dimensions of the octagon are further clues as to the intentions of the architects. The size is 72 times the size of the fundamental octagon which fits inside the Aum Crater. The number 72 is the size of the base angles of the star points of a pentagram. The radius of the octagon is 18 latitude degrees, where 18 is 1/2 the number of degrees in a star point of a pentagram. The reference to the pentagram is probably to show that the golden ratio φ is involved in the creation of the planet.

Finally, Fig. 6.6 shows my reason for including a discussion of the Aum Crater in this book. The figure shows the northeast side of an eighth octave octagon passing right through the centre of the Pentagram Pyramid. I shifted

Fig. 6.6: *The northeast side of an octagon with an interval ratio of 1296φ:16 passes exactly through the centre of the Pentagram Pyramid. Since the Pentagram Pyramid is used to survey out the positions of the upright pair of feet and the navel of the Vitruvian Martian, this octagon very likely depicts the role of the irrational number φ in the Martian body shape. A red cross marks the pentagram centre. USGS Astrogeology.*

the longitude of the Pentagram Pyramid centre slightly to the east from the position (231.6302° E) that I assigned it in Chapter 5. The Chapter 5 longitude enabled its NW star point to be aimed directly at the survey centre which I determined for Olympus Mons. However, the calculated survey centre has a small amount of unavoidable measurement error. I needed a more precise way to locate the longitude of the Pentagram Pyramid, and it was given to me by the octagon in Fig. 6.6. By changing the longitude of the Pentagram Pyramid centre to 231.6338° E, it aligned precisely to the octagon side. This particular octagon has the amazing interval ratio of 1296φ:16 which is not a harmonic interval at all. Rather it is an interval based on the irrational number φ, the value of the golden mean which is encoded in the pentagram in many ways. The number 1296 is the square of 36 which is the number of degrees in the star point of a pentagram. As well, the number 1296 is equal to 18 x 72 where 18 is half the number of degrees in the star point of a pentagram, and 72 is the number of degrees in the base angles of a pentagram star point. The interval ratio of 1296φ:16 can also be expressed as 81φ:1 by dividing both the numerator and the denominator of the interval ratio by 16. The number 81 is equal to 3 x 27 where 27 is 1/4 of the number

of degrees between the sides of a pair of adjacent star points of a pentagram. So the interval ratio of this octagon encodes not only the golden mean but also all of the angles to be found in the pentagram. It is because of this that I made the assumption that the Martian architects intended this special octagon to pass exactly through the centre of the Pentagram Pyramid. The positioning of this octagon can be considered to be highly accurate since the coordinates of its centre are numbers related to sacred geometry. The longitude is 60° E (DPPM) = 208.1047° E and the latitude is $(9/4)(e^2)°$ S = 16.6254° S. The abbreviation "DPPM" stands for "Dagger Peak Prime Meridian" which is one of the ancient prime meridians that I discovered on Mars.[3] It is located at the longitude of 148.1047° E, and its decimal fraction is based on the average of the decimal fraction estimates of 4 ancient prime meridians which are separated by exact integer values.[3]

Construction of the Square

With the alignment of the Pentagram Pyramid, I now had the means to locate the true survey centre of Olympus Mons with considerable accuracy. This in turn would allow me to locate and assemble the Vitruvian Martian. The first thing then that needed to be done was to locate the true survey centre of Olympus Mons which marks the middle of the bottom line of the Vitruvian Martian square. Using starting assumption #3 from the beginning of this chapter, we know that the latitude of the centre of the top line of the square at Pavonis Mons is $\varphi°$ N (planetographic) = 1.5989° N (planetocentric). This will be the latitude of the southeast end of the midline of the square. From this we can calculate that the northwest end of the midline of the square between Olympus Mons and Pavonis Mons has a latitude of 18.3649° N. This calculation is possible since assumptions #1 and #2 state that the length of this line is 1518.822 km and that it has a counterclockwise bearing angle of 49.1318°. Thus the latitude of the true survey centre of Olympus Mons has to be 18.3649° N. A rhumb line with a counterclockwise bearing angle of $atan(1/(\varphi\sqrt{5}))°$ can now be drawn from the Pentagram Pyramid centre towards Olympus Mons. The point where this line crosses the latitude of 18.3649° N marks what I postulate to be the true survey centre of Olympus Mons. It has the coordinates of 227.3272° E 18.3649° N. The midline of the square with a length of 1518.822 km and a counterclockwise bearing angle of 49.1318° can now be drawn from this point to Pavonis Mons. The southeast end of the midline has the coordinates of 247.0769° E 1.5989° N and marks the centre of the top line of the square at Pavonis Mons.

My newly determined estimate of the true survey centre of Olympus Mons, together with the previous survey crater estimate (yellow cross), is

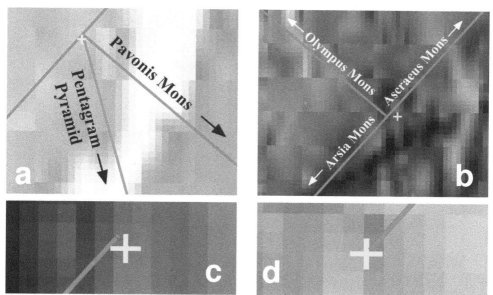

Fig. 6.7: *Fit of the new Vitruvian Martian model to the 4 giant mountains. In image a, the intersection of the red line from Pavonis Mons with the blue line from the Pentagram Pyramid at a latitude of 18.3649° marks the location of the middle of the bottom line of the square at the true survey centre of Olympus Mons. In image b, the intersection of the 2 lines marks the fit of the middle of the top line of the square at Pavonis Mons. In image c, the end of the red line marks the fit of the northeast top corner of the square to Ascraeus Mons. In image d, the end of the red line marks the fit of the southwest top corner of the square to Arsia Mons. The crosses in each image represent the survey centres of the mountains obtained from survey craters. Note that the survey centres are very close to the model components except for Pavonis Mons. The distances from survey centres are 0.473 km (Olympus Mons), 1.588 km (Pavonis Mons, 0.544 km (Ascraeus Mons) and 0.172 km (Arsia Mons). USGS Astrogeology.*

shown in Fig. 6.7a. They are only 0.473 km apart from each other. The midpoint of the distance of the midline from Olympus Mons to Pavonis Mons is now the location of the centre of the Vitruvian Martian square, and it occurs at 237.3299° E 9.9819° N. Incidentally, if I had chosen to go with the value of 25Φ° instead of atan(1/(φ√5))° for the counterclockwise bearing angle of the line from the Pentagram Pyramid, the longitude of the postulated true centre of Olympus Mons would only be 5.6 meters west of that obtained with the value of atan(1/(φ√5))°.

The next step is to add the top line of the Vitruvian Martian square. This can be accomplished by creating a line having a clockwise bearing angle of atan(e/π) = 40.8682° and a length of 1518.822 km. By placing its midpoint right at the Pavonis Mons end of the midline coming from Olympus Mons (Fig. 6.7b), the northeast end of the line will terminate

near the survey centre for Ascraeus Mons (Fig. 6.7c) and will be $R/(2\sqrt{5}) =$ 759.411 km from the midpoint at Pavonis Mons. The southwest end of the line will terminate near the survey centre for Arsia Mons (Fig. 6.7d) and will also be $R/(2\sqrt{5}) = 759.411$ km from the midpoint at Pavonis Mons. The distances of the intersection points in images a and b and the termination points in images c and d from the survey centres (yellow crosses) of the mountains are less than or equal to 0.544 km except for Pavonis Mons which is 1.588 km away. The magnitude of the discrepancy with the survey centre of Pavonis Mons is too large for this survey centre to have been designed to fit the centre of the top of the square. Hence, its purpose must have been restricted to marking the Pavonis Mons Prime Meridian (PMPM) instead. As mentioned in Chapter 5, the PMPM is one of the ancient prime meridians that I have discovered on Mars.[3]

For the bottom line of the square fitting the Vitruvian Martian, the midpoint of a line with a length of 1518.822 km and a clockwise bearing angle of $atan(e/\pi) = 40.8682°$ (i.e., parallel to the top line of the square) is

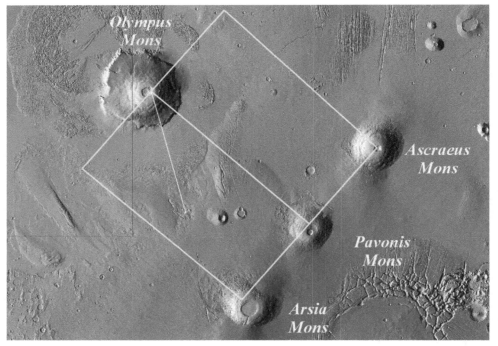

Fig. 6.8: *The completed square which fits the Vitruvian Martian. The midline of the square runs from Olympus Mons to Pavonis Mons. The white line from the centre of the Pentagram Pyramid (tiny white star) has a counterclockwise bearing angle of $atan(1/(\varphi\sqrt{5})) = 15.4504°$. The point where this line reaches the latitude of 18.3649° N marks the location of the true survey centre of Olympus Mons. This centre is then used to correctly position the entire square. USGS Astrogeology.*

	Longitude	Latitude
Ascraeus Mons	255.5235 ° E	11.2874 ° N
Pavonis Mons	247.0769 ° E	1.5989 ° N
Arsia Mons	238.6704 ° E	8.0895 ° S
SW corner	218.6938 ° E	8.6764 ° N
Olympus Mons	227.3272 ° E	18.3649 ° N
NW corner	236.4632 ° E	28.0533 ° N

Table 6.1: *Coordinates of the corners (Ascraeus Mons, Arsia Mons, SW corner and NW corner) of the square fitting the Vitruvian Martian. Coordinates are also given for the midpoint of the top side of the square at Pavonis Mons and the midpoint of the bottom side of the square at Olympus Mons.*

placed at the location of the true survey centre of Olympus Mons (Fig. 6.7a). Both ends of the line will extend a distance of $R/(2\sqrt{5}) = 759.411$ km from the midpoint on Olympus Mons. The northeast end of this line is then joined to the northeast end of the top line of the square fitting the Vitruvian Martian at Ascraeus Mons (Fig. 6.7c). The southwest end of the line is joined to the southwest end of the top line of the square at Arsia Mons (Fig. 6.7d). This completes the construction of the square (Fig. 6.8).

The coordinates of all the corners of the square together with the midpoint of the top side of the square at Pavonis Mons and the midpoint of the bottom side at Olympus Mons are shown in Table 6.1. The distances covered by the lines of the square are shown in Table 6.2. The midpoint of the top line of the square at Pavonis Mons is at a distance of $R/(2\sqrt{5}) = 759.411$ km from the corners of the square at Ascraeus Mons and Arsia Mons. The midline of the constructed square between Pavonis Mons and Olympus Mons is equal to the theoretical distance of $R/\sqrt{5} = 1518.822$ km. The midpoint of the bottom line of the square at Olympus Mons is at a distance of $R/(2\sqrt{5}) = 759.411$ km from the NW and SW corners of the square. However, the northeast side of the square between Ascraeus Mons and the NW corner is 66.484 km less than the theoretical distance of 1518.822

Table 6.2: *Lengths and bearing angles of components of the Vitruvian Martian Square. Clockwise bearing angles are negative, counterclockwise bearing angles are positive.*

Distance		Theoretical		Actual	Difference	Bearing
From	To	Formula	(km)	(km)	(km)	(°)
Pavonis Mons	Ascraeus Mons	$R/(2\sqrt{5})$	759.411	759.411	0.000	-40.8682
Arsia Mons	Pavonis Mons	$R/(2\sqrt{5})$	759.411	759.411	0.000	-40.8682
Pavonis Mons	Olympus Mons	$R/\sqrt{5}$	1518.822	1518.822	0.000	49.1318
Olympus Mons	NW corner	$R/(2\sqrt{5})$	759.411	759.411	0.000	-40.8682
SW corner	Olympus Mons	$R/(2\sqrt{5})$	759.411	759.411	0.000	-40.8682
Ascraeus Mons	NW corner	$R/\sqrt{5}$	1518.822	1452.338	-66.484	46.8215
Arsia Mons	SW corner	$R/\sqrt{5}$	1518.822	1542.627	23.805	49.8925

km, and the southwest side of the square between Arsia Mons and the SW corner is 23.805 km longer than the theoretical distance of 1518.822 km. The bearing angles of the northeast and southwest sides are also distorted, being 2.3103° less than the theoretical value of 49.1318° for the northeast side and 0.7606° more than 49.1318° for the southwest side. This causes the 90° angles of the square to be 92.3103° at Ascraeus Mons, 90.7606° at Arsia Mons, 87.6897° at the NW corner and 89.2394° at the SW corner.

Since the square is placed on a spherical surface rather than on a 2-dimensional flat surface, it cannot avoid being distorted. Either the 90° angles or the length of the sides, or both, have to be altered. If the 90° angles are maintained, the bottom side of the square which passes through Olympus Mons becomes deviant in length in addition to the northeast and southwest sides of the square. The bottom line of the square would be 75.607 km short of theoretical. Also the northeast and southwest sides of the square would be too close to the northeast and southwest points of the pentagram (see below). Hence, I chose the solution of maintaining the theoretical distance of the bottom side of the square in harmony with the top side of the square.

It is easy to make the erroneous assumption that the distance covered by the sides and midline of the square is uniform along the course of the lines in Fig. 6.8. This is far from the case. On a Mercator projection map, as a line moves from lower latitudes to higher latitudes, the same length of line covers less distance. The segment of the line between Pavonis Mons and Ascraeus Mons has to be slightly longer than the segment of the line between Arsia Mons and Pavonis Mons. This is because Ascraeus Mons lies further from the equator than Arsia Mons. Hence, the midpoint of the line drawn on the map between Arsia Mons and Ascraeus Mons is 1.811 km northeast of the midpoint of the distance covered by the top of the Vitruvian Martian square. The true midpoint of the distance occurs just west of the survey centre for Pavonis Mons. Similarly, the midpoint of the line on the map between Pavonis Mons and Olympus Mons (the midline of the square in Fig. 6.8) is 9.866 km northwest of the midpoint between the mountains based on the actual distance covered on the spherical surface. As one gets closer to Olympus Mons, the latitude increases and hence, a longer line is needed to cover the same distance as would be needed for regions closer to Pavonis Mons. The map line from Pavonis Mons to Olympus Mons is 1.4% longer than the map line from Arsia Mons to Ascraeus Mons even though they cover the same amount of distance. Since the midline is nonlinear, when it comes to determining the locations of the navel, the centre of the square and the centre of the pentagram, positions must be determined from actual distances rather than from the lengths of line segments on the map line between Pavonis Mons and Olympus Mons.

Construction of the Circle and Triangle

In order to construct the circle which fits the Vitruvian Martian, we first need to calculate the size of the radius r of the circle. The model requires that for a square side length (s) of 1518.822 km, the radius (r) of the circle for the Vitruvian Martian needs to be 924.540 km. This can be calculated from the equation in Fig. 1.2 in which:

$$s = r + r \times \cos(50) = r(1 + \cos(50))$$

Rearranging the equation, we get r in terms of s:

$$r = s/(1 + \cos(50))$$

Thus: **r = 1518.822/(1 + 0.64279) = 924.540 km**

From the model, the navel is located on the midline of the square, r units above the bottom pair of feet represented by the midpoint of the bottom side of the square. On Mars, the centre of the bottom side of the square is at the newly calculated survey centre of Olympus Mons (Fig, 6.7a), so the navel lies 924.540 km southeast of this point on the line between Olympus Mons and Pavonis Mons. Its coordinates have the value of 239.4633° E 8.1591° N.

Besides the Olympus Mons survey centre, there are 4 other important points that lie on the circle for the Vitruvian Martian. These are the pair of spread-apart feet and the middle fingers of the hands of the upward reaching arms. The spread-apart feet create an equilateral triangle with the navel, and all sides cover a distance equal to the length of the radius (r) of the circle in the model. However, the need to place this triangle on the spherical surface of Mars creates distortions. The angles have to be altered and/or the lengths of the sides have to be made unequal for the triangle to fit. If you opt for preserving the 60 degree angles of the equilateral triangle, the side to the right foot has to be 13.202 km shorter than the radius size of 924.540 km. The side to the left foot ends up being 10.252 km longer than the radius length, and the base of the triangle (the line between the feet) is 19.049 km shorter than the radius. However, if you construct the triangle so that it maintains the height ($r\sqrt{3}/2 = 800.675$ km) and base required by the theoretical model, and you centre the base at 228.9859° E 16.9975° N so that it extends r/2 km on both sides of the midline, the side to the right foot will be 5.042 km shorter than r km, and the side to the left foot will 11.586 km longer than r km. This assumes that the base has a clockwise bearing angle of $\operatorname{atan}(e/\pi) = 40.8682°$ (i.e., it is parallel to the top line of the square). However, the angle at the navel will be 61.063°, the angle at the right foot will be 59.073° and the angle at the

left foot will be 59.864°. I decided to go with the solution that maintains the theoretical distance for the base and height of the triangle rather than the equal 60° angle solution. The reason for this choice is that this solution is analogous to the solution which maintains the integrity of the theoretical distance of the bottom line of the square passing through Olympus Mons. It also mimics the design of the isosceles triangle fitting the 4 giant mountains in which both the base and the height are exactly equal to the sacred geometry formula of $R/\sqrt{5}$ km. In addition, 2 of the pentagram star points are located at the positions of the spread-apart pair of feet, and this solution to the triangle improves the fit of the pentagram by being faithful to the theoretical length of the base of the triangle.

There is very little distortion in the fit of the circle to the tips of the middle fingers of the upward pair of arms. These are the locations where the top line of the square intersects with the circle (the sites which the middle fingers of the upward pair of arms touch), and they are both placed 708.238 km from the midpoint of the top line of the square at Pavonis Mons. When radius lines are drawn from the navel to these 2 locations, the angle made with the midline of the square is 50.073° for the upward pointing finger of the right hand and 49.948° for the upward pointing finger of the left hand, rather than the theoretical value of 50° for both instances. The distance of the radius line to the finger of the right hand is 7.264 km less than the theoretical distance of 924.540 km. The distance to the finger of the left hand almost matches the theoretical distance, being only 13 meters shorter. Thus the errors in the angles and distances are very small. The reason why the errors are so small is because the middle of the top side of the square is very close to the equator. This allows for the nonlinearity of the northern half of the top side of the square to be similar (but not quite an exact match) to the southern half of the top side of the square. The fact that the navel is located at 8.1591° N rather than on the equator is another source of the slight distortions.

The fit of the circle and the triangle, as well as the lines from the navel to the intersection points of the circle with the top line of the square, are shown in Fig. 6.9. There is a small amount of distortion in the curvature of the circle to allow it to fit the modified radius distances of the lines to the positions of the spread-apart feet and to the tips of the middle fingers of the upward pair of arms. There are also small distortions in the angles of the equilateral triangle and in the angles between the midline and radius lines to the middle fingers of the upward pair of arms. All of these distortions are small enough to not be noticeable in the figure. Even the square, which is the most distorted shape, has an acceptable appearance of a square.

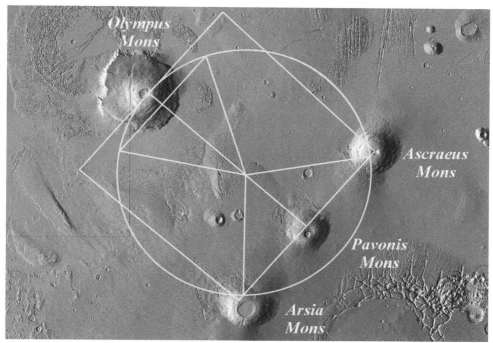

Fig. 6.9: *The circle, equilateral triangle and radii to the intersection points of the circle with the top line of the square for the Vitruvian Martian. There are slight distortions in the curvature of the circle, in the side lengths and angles of the equilateral triangle, and in the distances of the radii to the top line of the square and in the angles which these radii make with the midline of the square. USGS Astrogeology.*

Construction of the Pentagram

The tips of the 2 bottom star points of the pentagram which fits the Vitruvian Martian are located at the 2 ends of the base line of the equilateral triangle which has been constructed in the previous section. The construction of the rest of the pentagram starts with locating the northeast star point of the pentagram on the right side of the body and the southwest star point of the pentagram on the left side of the body. These star points lie at the ends of the line which forms the horizontal line of the pentagram in the theoretical model. To construct this line, the centre of a line with a length equal to $r\varphi = 1495.937$ km and a clockwise bearing angle of $\mathrm{atan}(e/\pi) = 40.8682°$ (i.e., parallel to the top line of the square) needs to be placed at 240.4755° E 7.2913° N. These are the coordinates of a point that lies on the midline of the square 515.668 km from the top line of the square. The length of $r\varphi$ km is the length of a pentagram line where r is the length of the radius of the circle which fits

the Vitruvian Martian. The northeast end of the line locates the NE star point which can then be joined to the left foot to create a second line of the pentagram. It has a length which is 7.378 km less than the theoretical distance of 1495.937 km for a pentagram line. The southwest end of the first line locates the SW star point of the pentagram which can be joined to the right foot to create a third line of the pentagram. This line is only 0.099 km more than the theoretical distance for a pentagram line.

For the star point whose tip extends above the head of the Vitruvian Martian, from the theoretical model it can be calculated that the tip lies 27.763 km directly above the top of the head (i.e., the midpoint of the top line of the square). The tip has the coordinates of 247.4312° E 1.2924° N. When the lines from the spread-apart feet to the tip of this star point are constructed, it is found that the line from the left foot is 15.662 km longer than the theoretical distance of 1495.937 km. The line from the right foot is 12.287 km less than the theoretical distance.

The centre of the pentagram occurs on the midline of the square at 237.3391° E 9.9740° N. It is 164.415 km below the navel and is very close to the centre of the square which is 165.129 km below the navel. Thus the pentagram centre is only 0.714 km from the centre of the square. Assuming that the Martian anatomy is similar to that of the human, both centres would be near the top of the genitals of the Vitruvian Martian and hence are powerful fertility symbols.

The number of degrees in a star point of a true pentagram is 36°. However, placing the model on a spherical surface distorts the size of each of the star points. The star point at the left foot has an angle value of 35.816° and the star point at the right foot has an angle value of 35.250°. The size of the NE star point is 35.934° and that of the SW star point is 35.955°. All of these values are slightly less than 36°. The star point at the top of the head is 37.045° which is about 1° larger than 36°.

The fit of the completed pentagram is shown in Fig. 6.10. It integrates nicely with the square, circle and equilateral triangle. All lines which are parallel to the top line of the square which runs between Ascraeus Mons and Arsia Mons have been constructed so that they are faithful to theoretical distances, and are centred in terms of distance at the midline of the square. These include the top line of the square, the horizontal line of the pentagram, the base line of the equilateral triangle and the bottom line of the square. By doing so, all the geometrical figures are harmonious with each other, and distortions which are present in each of them due to placement on a spherical surface are minimized and hardly noticeable.

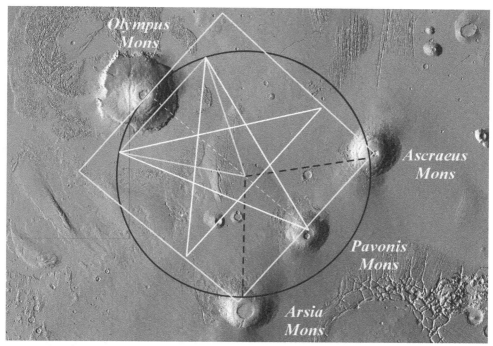

Fig. 6.10: *The complete fit of the theoretical model to the spherical surface of the planet at the site of the giant mountains. The square, circle, equilateral triangle and pentagram are harmonious with each other and show minimal distortion. USGS Astrogeology.*

Distances of the Pentagram Pyramid to Important Vitruvian Martian Sites

The relationship of the Pentagram Pyramid to the Vitruvian Martian goes beyond its role as a delineator of the navel and radius of the circle. It is also related to the Vitruvian Martian by having very meaningful distances to key sites in the body's structure (Table 6.3). All of the sites in Table 6.3 lie on the midline of the Vitruvian Martian square, marking the centres of all of the geometric shapes fitting the body shape as well as the top of the head (midpoint of the top line of the square at Pavonis Mons) and the bottom of the upright pair of feet (midpoint of the bottom line at Olympus Mons). The distance formula for the distance from the Pentagram Pyramid to Olympus Mons is $\sqrt{5}R/(5\varphi)$ km where R is the length of the equatorial radius of Mars. This formula is a very strong reference to the pentagram (which fits the Vitruvian Martian) with the use of 5, $\sqrt{5}$ and φ. Going towards the top of the head, we next have the distance formula of $R'/(3\sqrt{3})$ km for the distance to the centre of the equilateral triangle. R' km is the northern polar radius (= 3376.20 km) of Mars. This formula refers to

Table 6.3: *Distance formulae from the centre of the Pentagram Pyramid to sites along the Vitruvian Martian midline of the square.*

From Centre of Pentagram Pyramid to:	Theoretical Formula	km	Actual km	Difference km
Olympus Mons (midpoint of bottom line of square)	$\sqrt{5}R/(5\varphi)$	938.684	938.465	-0.218
Centre of equilateral triangle	$R'/(3\sqrt{3})$	649.750	650.940	1.190
Centre of square	$5R'/32$	527.531	527.786	0.254
Centre of pentagram	$\sqrt{3}\pi R/35$	528.001	527.773	-0.228
Navel	$e\varphi R'/27$	549.980	550.391	0.412
Navel	$\varphi R/10$	549.515	550.391	0.876
Navel	$\pi R/(12\varphi)$	549.507	550.391	0.885
Pavonis Mons (midpoint of top line of square)	$\sqrt{2}R'/(3\sqrt{3})$	918.885	918.932	0.047

the number of sides in a triangle and to the height of an equilateral triangle which has $\sqrt{3}$ as a factor. The centre of the square comes next with a distance formula of $5R'/32$ km. This formula refers to the number of equal sides in a square with 4 being a factor of the denominator twice. It also refers to the 5 star points of a pentagram. The distance formula of $\sqrt{3}\pi R/35$ km to the centre of the pentagram fitting the Vitruvian Martian refers to the circular nature of the pentagram with the use of π. As well, the denominator of 35 is divisible by 5, the number of star points in a pentagram. The $\sqrt{3}$ is a factor in the height of an equilateral triangle. I found 3 interesting formulae that fit the distance to the navel. The first of these is the formula of $e\varphi R'/27$ km. While this does not refer to the circle, it does refer to the pentagram with the use of φ and the number 27. The latter is $1/4$ the size of the angles between the star points of a pentagram. The use of the value of e could also be taken as a reference to a pentagram since an endless series of nested pentagrams can be created either by repeatedly multiplying the pentagram lines by φ^2 or by repeatedly dividing the pentagram lines by φ^2. As worked out in *Intelligent Mars I*:[1]

$$\mathbf{L' = Le^{2n(\ln(\varphi))}}$$

where n is an integer giving the number of iterations for expansion (positive n) or contraction (negative n), L is the original length of the lines and L' is the new length of the lines. The quantity of $2 \times \ln(\varphi)$ can be considered to be the rate constant of expansion or contraction and it is approximately equal to 0.9624 which is fairly close to 1. Since this formula uses e, the expansion or contraction is in a format which shows very

clearly a way in which e can symbolize the pentagram. The second distance formula to the navel is φR/10 km. This is a pure reference to the pentagram with the use of φ and a denominator which has 5 as a factor. Incredibly, the third formula fitting the distance from the Pentagram Pyramid to the navel refers to all 4 geometric shapes fitting the Vitruvian Martian. This is the distance formula of πR/(12φ) km. The value of π refers to the circle, the value of φ refers to the pentagram and the value of 12 = 3 x 4 refers to the number of sides in a triangle and in a square. Finally, the distance formula of √2R'/(3√3) km to the midpoint of the top side of the square of the Vitruvian Martian at Pavonis Mons refers to both the square and the equilateral triangle. The value of √2 is a factor in the length of the diagonal of a square. The value of 3 refers to the number of sides of a triangle and √3 is a factor in the height of an equilateral triangle.

It should be noted that all of the distances of sites from the centre of the Pentagram Pyramid differ only by 1.190 km or less from the theoretical distance formulae. It should also be noted that all 6 of the basic irrational numbers (i.e., φ, π, e, √2, √3 and √5) are present in the distance formulae. This shows an amazing level of intelligence in the arrangement of all of these sites and presents very strong evidence for the existence of both the Pentagram Pyramid and the Vitruvian Martian.

References

1. *Intelligent Mars I: Sacred Geometry of the Mountains. Did Da Vinci Know?* Arthur Raymond Beaubien. Epiphi Productions, Ottawa, Ontario, Canada. 2015.

2. *Intelligent Mars III: Aum and the Architect.* Arthur Raymond Beaubien. Epiphi Productions, Ottawa, Ontario, Canada. 2020.

3. *Intelligent Mars II: The Code of the Craters.* Arthur Raymond Beaubien. Epiphi Productions, Ottawa, Ontario, Canada. 2019.

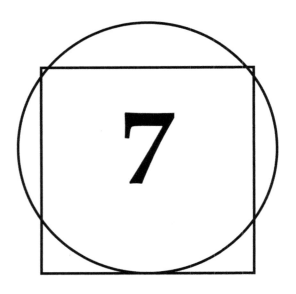

Constructing the Virtual Vitruvian Martian From High Above

Having worked out the placement of the new model on the surface of Mars, we are left with the question of what method the Martians themselves would have used to create the Vitruvian Martian from starting information. There is no outline of the square, circle, equilateral triangle, pentagram or body shape on the surface of the planet that I could detect on the map. So unless there are markings on the planet below map resolution, it is very likely that the Vitruvian Martian exists in virtual form only. This brings us to a discussion about participatory sacred geometry, a term that I came up with in *Intelligent Mars II* [1] to describe how the Martian architects created geometric shapes by providing only partial information to the observer. Basic starting information is supplied, but the observer has to fill in the blanks in order to arrive at the final product. In the case of polygonal-shaped craters (craters whose perimeters have the approximate shape of a square, pentagon, hexagon or octagon), straight line segments of the crater perimeter are present on most of the sides of the geometric shape, but the observer has to complete the picture by fitting the appropriately sized polygon to the segments. Hence, the observer has to be a co-creator. This is somewhat akin to quantum mechanics where the observer has an important impact on an uncollapsed wave function. The purpose of

participatory sacred geometry would seem to be to conceal artificiality of structures in order to avoid detection from enemies. However, it may also be a fundamental aspect of Martian spirituality which requires a participatory rather than passive role of the individual.

Some of the basic starting material provided by the Martian architects for the construction of the Vitruvian Martian consists of the survey craters for Ascraeus Mons, Arsia Mons and Olympus Mons. These are used to determine the coordinates of the survey centres of these mountains, allowing the observer to create the top line of the square which fits the Vitruvian Martian, and to discern the position of the middle of the bottom line of the square. The survey centre of Pavonis Mons is too far away from the middle of the top line of the square to actually fit the square. This survey centre was used instead to mark the Pavonis Mons Prime Meridian and the latitude of $\varphi°$ N in planetographic coordinates. The line between the survey centres of Ascraeus Mons and Arsia Mons forms the top of the square. The middle point of the distance covered by the top line of the square occurs at a latitude of exactly $\varphi°$ N (planetographic). When this point is joined to the survey centre of Olympus Mons, it creates the midline of the Vitruvian Martian square.

To be useful to an observer trying to construct the Vitruvian Martian, the survey centres of the mountains have to be accurately determined. I was only able to come up with close estimates of the survey centres from the survey craters since the available maps had too low a resolution to make fully accurate measurements. It is a reasonable assumption that an observer from a vantage point many kilometers above the surface of the planet would be able to accurately determine the survey centres from survey craters which would be in plain view. In order to do this, however, the observer would need to be able to measure distance accurately on the surface of the planet. The architects of the Martian topography provided a means for accurate calibration of distance from a range of altitudes by constructing several calibration markers visible from outer space.[2] One such marker is the distance between the 2 large craters on Ulysses Tholus which is equal to 1 latitude degree or 59.275 km (Fig. 7.1). As stated in Chapter 5, the distance covered by a latitude degree is constant independent of latitude, and is equal to the distance covered by a longitude degree measured at the equator. Another more sophisticated marker lies on the top of Pavonis Mons. It is a multi-segmented ridge which provides a measure of the distances covered by regular, big and sacred degrees as well as 1/50 of a radian (Fig. 7.2). In order to understand Fig. 7.2, you will need to know about my discovery of several degree systems used by the Martian architects.[1] I have found very good evidence that in addition to the 360 degree system which we use on planet Earth,

Fig. 7.1: *The distance between the 2 large craters on Ulysses Tholus is 1 latitude degree. The imaginary line connecting the centres of the craters has a bearing angle of 27° in the counterclockwise direction. USGS Astrogeology.*

the Martians used a 320 degree system and a 288 degree system. The size of a degree in the 320 degree system is 1.125 latitude degrees (= 66.684 km)

Fig. 7.2: *A ridge on the top of Pavonis Mons is composed of several sections which provide a measure of all the fundamental degree systems that I have found to be used on Mars. USGS Astrogeology.*

and the size of a degree in the 288 degree system is 1.250 latitude degrees (= 74.093 km). I call the degrees of the 320 degree system *big* degrees and those in the 288 degree system *sacred* degrees. To distinguish between the degree systems, my custom has been to use a double degree sign for big degrees and a triple degree sign for sacred degrees. Thus 12 big degrees is written as 12°° and is equal to 13.5°. The value of 18 sacred degrees is written as 18°°° and is equal to 22.5°. In addition to using several degree systems, the Martians also used radians (rads) where 1 rad = 3396.19 km, the length of the planetary radius. More conveniently, they used units of 1/50 rad = 67.924 km or 1/100 rad = 33.962 km.

Another piece of basic starting information for constructing the Vitruvian Martian is the NW star point of the Pentagram Pyramid which points directly at the true survey centre of Olympus Mons. This is a second way in which the true survey centre of this mountain can be obtained. However, on its own, the line from the Pentagram Pyramid passing through the NW star point to Olympus Mons does not give enough information to establish the middle of the bottom line of the square on Olympus Mons. The latitude of this point must also be provided. In Chapter 6, it was calculated to be 18.3649° N by determining the latitude of the northwest end of a line having a counterclockwise bearing of $\mathrm{atan}(\pi/e)°$, a length of 1518.822 km, and a latitude of $\varphi°$ N (planetographic) for its southeast end. An observer on Mars would likely already have this information and could therefore readily obtain the Olympus Mons survey site by using the NW star point of the Pentagram Pyramid.

By using the true survey centre of Olympus Mons in combination with the NE star point of the Pentagram Pyramid, the pyramid can be used as a convenient way to measure out the radius of the circle and to locate the position of the Vitruvian Martian navel. In order to show how this could be accomplished, we first need to know how the NE star point was used as a pointer to the navel. In *Intelligent Mars I*,[3] it was found that a rhumb line from the centre of the Pentagram Pyramid passing through the NE star point pointed to the navel of the Vitruvian Martian. However, the position of the navel was based on my estimates of Da Vinci's circle and square. Because Da Vinci's circle is smaller than the circle in my new theoretical model, its centre ends up being below the centre of the new model's circle. Also, my previous measure of the Da Vinci's square size was slightly larger than in the new model (side length = 181.383 mm rather than 181.126 mm). This causes the circle radius to be slightly smaller in proportion to the square and thus was another factor in pushing the centre of the circle (the navel position) lower in relation to the position of the top of the head. A third complication is that the square was not positioned as accurately on the planetary surface as the new

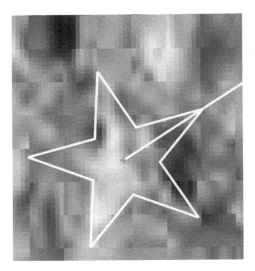

Fig. 7.3: *A line from the centre of the Pentagram Pyramid passing through the tip of the NE star point intersects the midline of the model square 4.670 km northwest of the navel. Note that the image on the right is at a higher magnification than the image on the left. USGS Astrogeology.*

model square since the true survey centre of Olympus Mons was not known at that time.

When a rhumb line is drawn from the centre of the Pentagram Pyramid through the tip of its NE star point and extended so that it intersects the midline of the square in the new model, it is found that the intersection point is 4.670 km below the navel position of the new model (Fig. 7.3). This was very puzzling at first since I was certain that the Pentagram Pyramid was constructed to point out the navel as well as the bottom of the feet of the pair of upright legs for the Vitruvian Martian. If the navel lay on a rhumb line which could be constructed from the architecture of the Pentagram Pyramid, then the all-important radius of the circle could be determined and, as well, the centre of the circle, by locating where the rhumb line crossed the midline of the square which runs between Olympus Mons and Pavonis Mons.

It then occurred to me that the answer to the problem of creating an accurate rhumb line from the Pentagram Pyramid must lie in the location of the marker for $\pi°$ N (planetocentric) on the ramp inside the Pentagram Pyramid (see Fig. 5.4). If you remember, I had not located the longitude of the marker with any precision. This marker must have been located so that, in combination with the tip of the NE star point of the Pentagram Pyramid, a rhumb line could be created which is precisely aimed at the navel of the Vitruvian Martian.

I calculated that the longitude of the marker of $\pi°$ N would have to be 231.6871° E in order for it to align the NE star point to the navel. This turns out to be only 168 meters west of the site where it would lie on the line from the centre of the Pentagram Pyramid to its NE star point. The

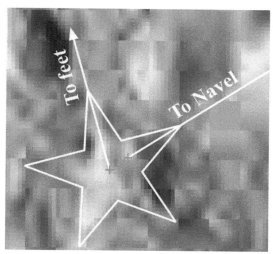

Fig. 7.4: *Lines from the Pentagram Pyramid to delineate the circle radius of the Vitruvian Martian. The rhumb line to the feet of the pair of upright legs on Olympus Mons goes from the centre of the Pentagram Pyramid through the tip of the NW star point. The rhumb line to the navel goes from the marker of π° N on the ramp through the tip of the NE star point. USGS Astrogeology.*

calculated location is well within the limits of the ramp and lies in the eastern half of the brightest pixel on the ramp. Fig. 7.4 shows how the Pentagram Pyramid is used to point to (1) the feet of the pair of upright legs on Olympus Mons by using the Pentagram Pyramid centre in alignment with the tip of the NW star point, and (2) the navel by using the marker of $\pi°$ N on the ramp in alignment with the tip of the NE star point. Both rhumb lines intersect the vertical midline of the square, one at the point where the midline intersects the bottom line of the square on Olympus Mons, and the other at the navel. This gives the position of the navel and the length of the radius of the circle.

Construction of the Equilateral Triangle

From the information provided by the survey craters and the Pentagram Pyramid an observer has by this juncture been able to obtain the location of the top side of the square, the midline of the square, the midpoint of the bottom side of the square, the location of the navel and the radius length of the circle. The observer can next focus on constructing the equilateral triangle. As was concluded in the previous chapter, the model of the equilateral triangle most likely chosen by the Martian architects to fit on a spherical surface was the one which maintained the theoretical lengths of both the height and base of the triangle. In this way it would be in harmony with the bisected isosceles triangle fitting the 4 giant mountains in which the base was equal to the height, both covering a distance of exactly $R/\sqrt{5}$ km. The sides of the isosceles triangle were allowed to be

distorted in length in order to fit the triangle on a spherical surface. In the case of the equilateral triangle, the base of the triangle is equal to the circle radius r = 924.540 km and the height is equal to r√3/2 = 800.675 km. The ratio between the height and base turns out to be 0.866025 (which is remarkable similar to the ratio of e/π = 0.865256, being only 0.09% greater). Hence, all that is needed for the construction of the equilateral triangle is to locate a point on the midline of the square which is at a fraction of 0.866025 of the radius line from the navel to Olympus Mons. Then a line having a length of r km and a clockwise bearing angle of atan(e/π)° would have to be centred at this point. This line would become the base of the equilateral triangle and its 2 ends would mark the positions of the right and left feet of the spread-apart pair of legs. By joining these ends to the navel, the 2 remaining sides of the equilateral triangle would be created. These 2 sides would be distorted in length, the side to the right foot being 5.042 km shorter than r km, and the side to the left foot being 11.586 km longer than r km. Hence, the circle has to be distorted in order to align with the feet but this would not be too noticeable as the deviations are a very small fraction of the circle radius (i.e., 0.55% for the right foot and 1.25% for the left foot).

An alternative approach to determining the positions of the right and left feet would be to create 4 radius lines between the navel and Olympus Mons (Fig. 7.5). To locate the right foot, the first radius line would be rotated 30.9272° in the clockwise direction about the navel. The second radius line would be rotated 75.1992° in the counterclockwise direction about the Olympus Mons survey centre. The intersection point of the 2 lines would mark the location of the right foot. To locate the left foot, the third radius line would be rotated 30.1361° in the counterclockwise direction about the navel. The fourth radius line would be rotated 74.7465° in the clockwise direction about the Olympus Mons survey centre. In this case, the radius line rotated about the navel is too short so its length would have to be extrapolated until it reached the radius line which was rotated about the Olympus Mons survey centre. The meeting point would mark the location of the left foot. The locations for the feet would then be joined to create the base of the triangle. The values of the angles of rotation required for this procedure would need to be known in advance, and this information was undoubtedly available to those who would be constructing the virtual Vitruvian Martian.

Locating the Tips of the Fingers of the Upward Arms

The positions of the tips of the middle fingers of the upward arms coincide with the locations where the circle intersects the top line of the square. The distance to these points from the midpoint of the top line of

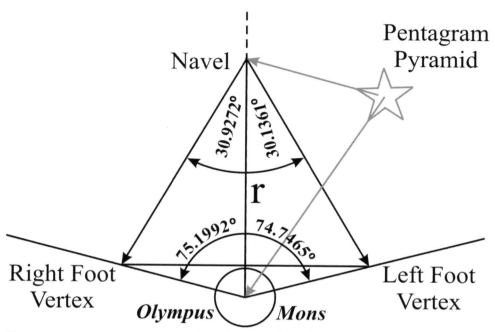

Fig. 7.5: *Diagrammatic representation of a method for the construction of the equilateral triangle of the Vitruvian Martian from outer space. The circle radius (r) and navel position are determined by the intersections of the midline of the square with rhumb lines (in red) emanating (1) from the centre of the Pentagram Pyramid and (2) from the marker of $\pi°$ N on the ramp of the pyramid. The radius line between the navel and Olympus Mons is replicated 4 times. Two of the lines are rotated about the navel and 2 are rotated about the survey centre of Olympus Mons, each at a specific angle (sizes shown on figure) with the midline. The intersections of these lines mark the positions of the feet of the spread-apart pair of legs. The radius line from the navel to the left foot has to be extended by 11.586 km to make an intersection with the radius line from Olympus Mons. The positions of the feet are joined by a line of length r = 924.540 km which forms the base of the equilateral triangle.*

the square is equal to r x sin(50) = 708.238 km for each finger where r = 924.540 km. These points could be measured out directly or they could be obtained by using 2 radius lines from the navel to Olympus Mons. To locate the position of the tip of the middle finger of the right arm, a radius line needs to be rotated in the clockwise direction about the navel by 129.9270° from the midline of the square (Fig. 7.6). It then needs to be shortened by 7.264 km to coincide with the point where the circle crosses the top line of the square. To locate the position of the tip of the middle finger of the left upright arm, a radius line from the navel to Olympus Mons needs to be rotated in the counterclockwise direction about the navel by 130.0520° from the midline of the square. It then needs to be shortened by only 0.013 km to coincide with the point where the circle

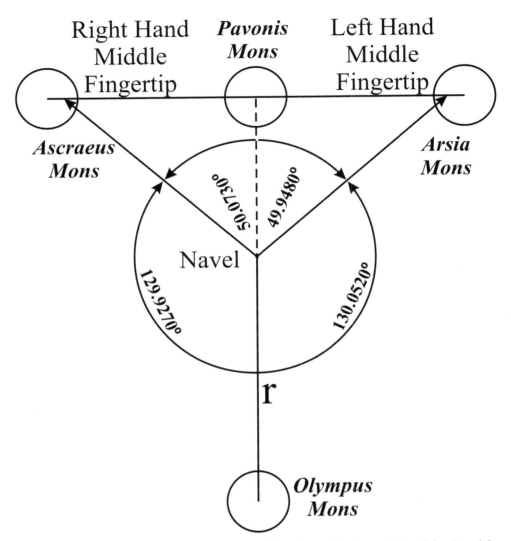

Fig. 7.6: *Diagrammatic representation of a method to determine the position of the tips of the middle fingers of the upward pair of arms from outer space. The radius line from the navel to Olympus Mons is duplicated twice. One of the lines is rotated about the navel by 129.9270° in the clockwise direction. Its intersection with the top line of the square marks the location of the right fingertip. The other line is rotated 130.0520° in the counterclockwise direction. Its intersection with the top line of the square marks the location of the left fingertip.*

crosses the top line of the square. The radius line to the right finger is 50.0730° from the midline of the square and the radius line to the left finger is 49.9480° from the midline of the square. These 2 radius lines are 100.0209° apart which is extremely close to the theoretical value of 100°.

Constructing the Pentagram

The positions of the feet for the spread-apart pair of legs (which have been determined from the fitting of the equilateral triangle) are the locations for the tips of 2 of the pentagram star points. The locations of the tips of the star points on the right and left sides of the upper body and the tip of the star point above the Vitruvian Martian's head remain to be determined. In keeping with my decision to maintain the theoretical length of the base of the equilateral triangle, I decided in the previous chapter to maintain the theoretical length of the line of the pentagram which is parallel to the top line of the square and runs just above the navel. The middle of this line lies on the midline of the square at a point which is equal to 0.085 x r or 78.615 km above the navel (Fig. 7.7). Hence, this point can be located by simply taking the fraction of 0.085 of a radius line (r = 924.540 km) and measuring it out along the midline above the navel. Then a line with a length of $r\varphi$ = 1495.937 km and a clockwise bearing angle of atan(e/π)°, (i.e., parallel to the top line of the square) needs to be centred at this point. The 2 ends of this line mark the positions of the tips of the star points on the right and left sides of the upper body. The star points can now be completed by connecting the left foot to the tip of the star point on the right side of the body (covers a distance which is 7.378 km less than $r\varphi$ km), and the right foot to the tip of the star point on the left side of the body (covers a distance which is 0.099 km more than $r\varphi$ km).

The tip of the star point above the head of the Vitruvian Martian can be created by locating a point 27.763 km directly above the top of the head (i.e., the midpoint of the top line of the square). This point has the coordinates of 247.4312° E 1.2924° N and it is the location of the tip of the upper star point of the pentagram. It is then a simple matter to join the right and left feet to this point with straight lines to create the final 2 lines of the pentagram. An alternative approach shown in Fig. 7.7 is to create a line whose length is close to $r\varphi$ = 1495.937 km and place one end at the location of the right foot of the spread-apart feet. This line needs to be rotated about the right foot position to create an angle of 71.2053° with the base of the equilateral triangle. Then a second line has to be created having a length about 20 km longer than $r\varphi$ km. One end is placed at the location of the left foot of the spread-apart feet. This line then needs to be rotated about the left foot position to create an angle of 71.7498° with the base of the equilateral triangle. The intersection of this line with the first line marks the tip of the pentagram star point above the head. The line from the right foot to the intersection point will be 12.287 km shorter than $r\varphi$ km and the line from the left foot to the intersection point will be 15.662 km longer than $r\varphi$ km. This completes the pentagram.

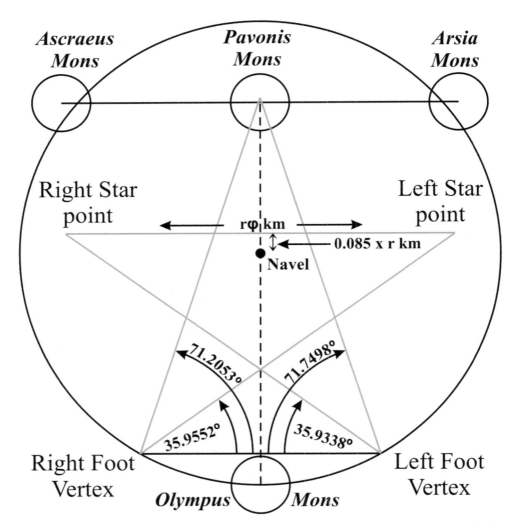

Fig. 7.7: *Diagrammatic representation of the construction from outer space of the pentagram which fits the Vitruvian Martian. A line with a length of rφ km and a clockwise bearing angle of atan(e/π)° is centred at a point which is 0.085 x r km above the navel. The ends of this line mark the tips of the star points lying on the right and left sides of the upper body. The right foot is then joined to the left star point tip location and the left foot is joined to the right star point tip location. The tip of the star point above the head of the Vitruvian Martian is formed by the intersection of 2 lines which are at specific angles (sizes shown on figure) from the base of the equilateral triangle.*

Construction of the Square

The simplest way to finish construction of the square is to create a line with a clockwise bearing angle of atan(e/π)° = 40.8682° and a length of

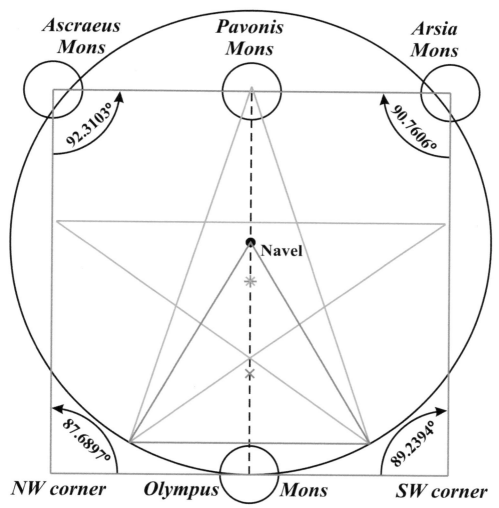

Fig. 7.8: *Diagrammatic representation of the construction of the square on the spherical planetary surface. A line covering a distance of R/√5 = 1518.822 km and having a clockwise bearing angle of atan(e/π)° is centred on Olympus Mons. The 2 ends of this line mark the NW and SW corners of the square. The line drawn from Ascraeus Mons to the NW corner is 66.484 km shorter than R/√5 km. The line drawn from Arsia Mons to the SW corner is 23.805 km longer than R/√5 km. Note that the 4 angles of the square deviate from having a size of 90°. The centre of the circle is the navel. The centre of the pentagram is the blue X on the midline below the navel. Just beneath this is the red cross marking the square's centre. The triangle's centre is at the green X on the midline.*

R/√5 = 1518.822 km where R is the planetary radius equal to 3396.19 km. Its midpoint then needs to be placed at the survey centre of Olympus Mons (Fig. 7.8). This line will extend R/(2√5) = 759.411 km in both

Shape	Distance of Centre From Top of Head (km)
Circle (navel)	594.283
Pentagram	758.698
Square	759.411
Equilateral Triangle	1128.066

Table 7.1: *Distances of the centres of the geometric shapes from the top of the Vitruvian Martian head. The centres occur on the vertical midline of the square. Note that the centre of the square is only 0.714 km further than the centre of the pentagram.*

directions, and the SW and NW corners of the square will lie at the ends of the line. It is then a simple matter to connect the SW corner with the southwest end of the top line of the square at Arsia Mons, and the NW corner with the northeast end of the top line of the square at Ascraeus Mons. Due to the curvature of the planet, the line from the SW corner to Arsia Mons is 23.805 km longer than the distance of $R/\sqrt{5}$ km, and the line from the NW corner to Ascraeus Mons is 66.484 km shorter than $R/\sqrt{5}$ km. The spherical surface of the planet also causes the angles of the square to deviate from 90°. Thus the angle at Arsia Mons is 90.7606°, at the SW corner it is 89.2394°, at the NW corner it is 87.6897°, and at Ascraeus Mons it is 92.3103°.

With the completion of the square, all of the geometric shapes that fit the Vitruvian Martian are now in place. The locations of the centres of the circle, pentagram, square and equilateral triangle all lie on the vertical midline of the square. Their distances from the middle of the top line of the square are shown in Table 7.1. Their locations are shown in Fig. 7.8. The navel is depicted as a small black circle, the pentagram centre as a blue X, the square centre as a red cross and the triangle centre as a green X.

All that remains to be done now is to overlay a sketch of a Martian figure. That would be the job of an artist rather than a geometer.

References

1. *Intelligent Mars II: The Code of the Craters.* Arthur Raymond Beaubien. Epiphi Productions, Ottawa, Ontario, Canada. 2019.

2. *Intelligent Mars III: Aum and the Architect.* Arthur Raymond Beaubien. Epiphi Productions, Ottawa, Ontario, Canada. 2020.

3. *Intelligent Mars I: Sacred Geometry of the Mountains. Did Da Vinci Know?* Arthur Raymond Beaubien. Epiphi Productions, Ottawa, Ontario, Canada. 2015.

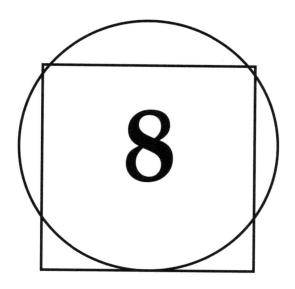

The Real Message of the Vitruvian Man

N early everyone assumes that the main purpose of Da Vinci's Vitruvian Man drawing was to demonstrate that the human body shape fits both a square and a circle. Most people also assume that the drawing was used to show the ideal human body proportions. The circle and square theme did indeed serve as a teaching aid on how our bodies conform to the principles of sacred geometry. But Chapters 2 and 3 show that Da Vinci had other objectives which he hid from the general public. He created slight deviations in the theoretical circle and square to guide insiders to the presence of a pentagram which the human body also fits in a major way. Nothing could be a more elegant reference to sacred geometry than the shape of a pentagram since the pentagram is the supreme embodiment of the golden ratio φ. The golden ratio is present in several ways in the structure of a pentagram[1] and it occurs throughout all of nature, including human body proportions where, for instance, the distance between the fingertips and the elbow is in golden ratio to the distance between the wrist and the elbow.

Despite the prominence of the sacred geometry message, it would seem that Da Vinci had a much deeper story to tell with his Vitruvian Man. The fact that he hid the pentagram suggests that he was using the pentagram as an occult symbol. Most people today assume that an upright pentagram (one star point at the top of the figure) is a positive symbol and that a reversed pentagram (two star points projecting

upward) is a symbol of evil with the 2 upright star points symbolizing the horns of the devil. The attribution of evil to the reversed pentagram seems to have arisen in the 19th century with the occultist Éliphas Lévi who incorporated a goat-headed Baphomet (a deity that the Knights Templar were accused of worshipping) into the inverted pentagram. The upright pentagram has been used in Judaism as a symbol of wisdom, mercy and justice, and in Christianity as a symbol of the 5 senses or the 5 wounds of Christ. How then could Da Vinci have used the upright pentagram in a way that would require him to hid it?

A very likely answer to this question can be found in Fig. 8.1. If we look at the fit of the pentagram to Da Vinci's Vitruvian Man and emphasize the lines that go from the star point at the top of head to the spread-apart pair of feet, we have a representation of the compass found in the traditional Freemasonry square and compass drawing (Fig. 8.2). Then if we emphasize the lower pentagram lines from the star points on the man's right and left sides of the body to where they intersect at the midline, we have a representation of the square found in the Freemasonry square and compass drawing. Despite the fact that this representation of the square is erroneous in its angle of 108 degrees instead of 90 degrees, its symbolism would be identical to that of the Freemasonry square. Although most people see the square and compass as architect's tools, there is another more insidious interpretation. The Freemasonry square can be used to represent a female in the missionary position and the compass to represent a male mounting her for intercourse. Pursuing this further, in the traditional Freemasonry square and compass, a large G symbol is very often placed in the centre between the square and the compass. We are told that the G stands for God or Geometry. However, this is very likely to be a diversion. What it probably stands for is "Generation" in the sense of generating new life either symbolically or in actuality. And what lies at this location in the Da Vinci drawing? None other than the *Genitals* of the Vitruvian Man, another very good possibility for the meaning of the G symbol. If this interpretation is correct, then Da Vinci was using the hidden pentagram as a powerful sex symbol and this would indicate that Freemasonry is fundamentally a sex cult. Using the pentagram as a sex symbol goes well beyond its use as a fertility symbol manifesting the golden ratio found everywhere in nature. Such usage would certainly ruffle the feathers of the Church hierarchy and force Da Vinci to keep it a secret. The sexual act symbolized by the square and compass would refer to illicit sexual behaviour performed in secret society rituals as a form of worship to Satan, not the sexual relations between a married couple. The fact that Da Vinci kept the pentagram hidden suggests that the Church hierarchy must have been

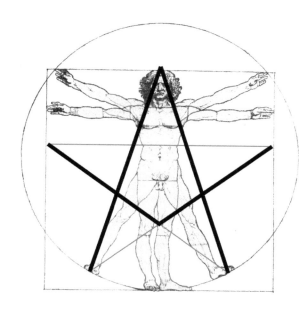

Fig. 8.1: *A shape analogous to the Freemasonry square and compass is contained in the upright pentagon. The 2 lower lines from the left and right star points to the body midline create a shape similar to a square even though the angle is 108° instead of 90°. It represents a female in the missionary position. The lines from the spread-apart pair of feet to the upper star point create a shape similar to a compass, and represent a male mounting the female. The genitals are in the centre similar to the position of the G in the Freemasonry symbol.*

Fig. 8.2: *The square and compass is the universal symbol of Freemasonry. It most often has a capital G in its centre which is said to represent God or Geometry. The square and compass symbol is generally considered to depict tools used by an architect. These tools are also said to teach a virtuous code of conduct. However, another interpretation is that they symbolize the sex act. The G would then represent the word "Generation" which refers to the generation of offspring resulting from the sex act. Drawing by MesserWoland, CC BY-SA 3.0, via Wikimedia Commons.*

well aware of the potential for this type of perverted symbolism to be attributed to the pentagram.

Da Vinci also successfully diverted everyone's attention to the square and the circle so that nobody ever noticed that the man in the drawing is not sketched in an anatomically correct manner (Fig. 3.1). The illustration contains several deviations from normality such as the lateral displacement of body parts from the body's midline. The most egregious violation of all is the inward twisting of the man's right knee in the upright pair of legs despite having the lower leg face straight ahead. This could only happen by breaking the leg below the knee. The excellent fit of these deviations to

the dual serpent shape of Ningishzida, the serpent fertility god, is remarkable. But why would Da Vinci go to the trouble of fitting his drawing to a serpent god? I have explored the fertility aspect of this god in Chapter 3. It fits right in with the pentagram which is a fertility symbol in its own right since it manifests the golden ratio which is found everywhere in nature. Also the centre of the pentagram and the centre of the square are located at the base of the penis which again emphasizes fertility. And it is likely that Da Vinci was using the pentagram as a sex cult symbol to illustrate promiscuous fecundity in the worship of Satan.

However, there seems to be a more sinister dimension to the fertility aspect of the dual serpent. The fact that the man's body follows the shape of the female serpent suggests that he himself has been created in the *likeness of a serpent*, and it is the female serpent that gives him birth. This has profound implications for humanity. It suggests that Da Vinci is saying that our god and creator is a serpent, not a male god with a beard, and certainly not the One Divine Absolute Being that we were taught to believe in our religions. The male serpent is also present and probably represents the male role in human creation, i.e., a sperm provider. But it is the female that gestates us, not the male and this may be the reason why Da Vinci makes her more prominent. So Da Vinci is probably saying that humanity has dual parents, a male and a female, and they are neither human nor the One Absolute God of Creation. Rather, he seems to be indicating that we have been created by a dual serpent god who is both female and male.

The dual serpent representing Ningishzida predates other symbols of a snake entwined about a rod such as the caduceus of Hermes, the Rod of Asclepius and the staff of Moses. Thus Ningishzida may have provided the inspiration for these similar symbols. The Rod of Asclepius (Fig. 8.3) is the staff of Asclepius, the Greek god of medicine, and it is associated with medicine and healing. This rod is used as a logo by a number of organizations associated with medicine all over the world. It depicts a single serpent encircling a rod. The Caduceus (Fig. 8.4) depicts 2 serpents entwined about a rod which has a pair of wings at its top section. This is the staff carried by Hermes in Greek mythology, by Hermes Trismegistus in Greco-Egyptian mythology, and by Mercury in Roman mythology. Hermes is considered to be the god of commerce, travelers and thieves. As Mercury, he is also known as a messenger, a trickster, a deceiver and a god of financial gain. In 1902, the caduceus was adopted by

Fig. 8.3: *The Rod of Asclepius.*

Fig. 8.4: *The Caduceus symbol used by the US Medical Corps.*

the Medical Department of the United States Army as the symbol for medicine instead of the Rod of Asclepius. Although some think this is wrong, it actually is in line with Ningishzida being a god of medicine. Ningishzida's father Ninazu was also associated with healing, and was also tied to the imagery of a snake. Ninazu's healing was mostly directed towards treating snake bites.

So we are led to believe that the caduceus is a symbol for healing. However, in line with the capacity of Hermes or Mercury to deceive and go after financial gain, the caduceus more likely is a symbol telling us that Ningishzida has an evil control over our health practitioners, public health institutions and pharmaceutical companies. This could be why western medicine is considered by some to be the leading cause of death in the United States causing over 780 thousand deaths per year.[2] The number of unnecessary antibiotics prescribed for viral infections is 20 million per year, the number of unnecessary medical and surgical procedures is 7.5 million yearly, and unnecessary hospitalizations is 8.9 million per year. It does not serve the public properly. Rather, it makes a lot of money for whoever runs the health industry, e.g. the Rockefellers. The failure of western medicine has prompted one critic[3] to comment as far back as 1932 that "[the emblem of Hermes] would seem more appropriate on a hearse than on a physician's car."

The double helix snake of the Caduceus and of Ningishzida is often looked upon as a representation of DNA. Could it be that the use of snakes to represent DNA gives the message that human DNA contains reptilian genes? This would explain why we have a reptilian brain in addition to our emotional brain and rational brain. Our reptilian brain is in charge of our basic primal drives such as self-preservation and reproduction. These give rise to behaviours such as aggression, flight, territorialism, sexual intensity and ritual displays. The reptilian brain is an instinctual brain which operates independently of our conscious brain. It has no conscience, but simply acts in its own interest.

All of this suggests that Da Vinci is telling us that humanity has been genetically engineered by a race of serpent beings. The Vitruvian Man drawing is fundamentally an icon of a serpent god, proclaiming its dominion over humanity. Although it is unlikely that Da Vinci would

have understood the concept of DNA in his era even with his privileged Masonic knowledge, his drawing nevertheless appears to attribute human creation to Ningishzida. From the vantage point of modern science, the actual role of the serpent god in creation might have been to genetically alter true human DNA in order to incorporate a reptilian brain which would make us controllable by a reptilian race. After infringing on the Divine copyright for human genetics, the serpents likely proclaimed ownership over us, ownership of a patent which they say allows them to totally enslave us, and use and abuse us for any purpose which suits them. This is remarkably similar to the way companies like Monsanto infringe on the Divine patent for seeds by genetically modifying them. They then criminally proclaim ownership of a patent for a seed into which they have only introduced a slight change, a change which is usually deprecatory rather than an enhancement, and steal all of the rest of the technology that is present in the seed, including its life principle.

In addition to the DNA theme, the perversion that Da Vinci introduces with Ningishzida may extend to the yogic concept of the chakras (energy centres in the form of wheels or vortexes) and the Kundalini Energy. I dismissed this possibility earlier in Chapter 3 since the chakras are located only in the upper half of the body. However, Da Vinci may have intended to show a perverted representation of the chakra/Kundalini system. In this scenario, the Kundalini Energy, which normally lies dormant in the form of three and a half coils in the sacrum bone until raised, would now be represented by dual serpents in a fully raised configuration. Note that each of the serpents is stretched out in the form of three and a half coils. The false Kundalini Energy would oppose the true Kundalini Energy and would work towards keeping it dormant. The first 6 chakras created by the serpents would probably correspond to the coils which the serpents make as they twist their way up the body. Each coil creates a circular space for an energy vortex to rotate. The first chakra, normally associated with innocence and grounding is now located at the feet and ankles, lending support to the serpents and all the other chakras. The second chakra, normally associated with creativity is now located at the level of the lower legs, and the 3rd chakra, normally associated with peace, generosity and nurturing is now located at the level of the upper legs. The 4th chakra is the central chakra. It normally is associated with the heart, bringing unconditional love, compassion, and self-confidence. With the serpents, it is now located at the level of the genitals, probably representing instinctual behaviour which is now central. The 5th chakra is normally located at throat, and it is associated with communication, diplomacy and teamwork. Now it is located at the chest, probably indicating pride and pompousness. The 6th chakra, normally located in the centre of the lower forehead, is

associated with forgiveness and humility. With the serpents it is now located at the level of the head, probably representing cunning and deceit. The 7th chakra in the yogic system is located in the frontal lobe part of the limbic system. When raised, the true Kundalini Energy pierces through the anterior fontanelle region at the top of the head and unites our individual consciousness to Universal Consciousness. The 7th chakra created by the serpents would probably be located at the level of their heads. The presence of the reptilian heads would make our consciousness susceptible to joining the consciousness of the serpent god rather than to the Infinite Divine Consciousness. All of our normal chakras are thus under the control of the serpents. The chakra energies are kept unbalanced and blocked which leads to illness and unhappiness. Thus, rather than representing our yogic chakra system, the intent of Da Vinci's fitting of the man's body to the serpents would more likely be to show that the serpent chakra system is *superimposed* on our yogic chakra system to keep it repressed.

The presence of 2 gryphons in the depiction of Ningishzida (Fig. 3.2) is curious. They are each holding what looks to be a sword. Together they enclose the 2 serpents. Are they supporting the 2 serpents with the swords, helping them to coil around the rod? Snakes don't really need this kind of support since they are perfectly capable of coiling around an object. Hence, a more likely explanation is that the gryphons are confining the serpents – confining our DNA so that it stays within the control of the reptiles. We have been bred and trained to obey them, to look to them for our knowledge and guidance, and to worship them as gods and rulers. Alternatively or in addition, the 2 swords, together with the central rod that the serpents coil themselves around, might represent the 3 major energy channels in the yogic system. The central rod would represent the central (sushumna) channel through which the Kundalini Energy rises. The rod which would be on the Vitruvian Man's right side would represent the pingala channel which is the channel of action, and the rod on his left side would represent the ida channel which is the channel of pure desire. The ida channel is considered feminine and the pingala channel masculine so the gryphons are reversed for the lower chakras. However, the channels in the yogic system cross over at the 6th chakra, so above this level the gender of the gryphons is correct. Perhaps in the case of the gryphons, the ida and pingala channels don't cross and are simply reversed to keep us unbalanced, thus placing the ida channel entirely on the man's right and the pingala channel entirely on the man's left. This would be in keeping with the practice of Satanists to reverse everything in order to assert an evil control. Hence, the presence of the 2 gryphons could be showing that these creatures control our ida and pingala channels as well as Ningishzida controlling our chakras and our sushumna channel. The female gryphon

would control our ida channel, creating a tendency towards lethargy, depression and passivity. The male gryphon would control our pingala channel creating a tendency towards egotism, aggression and the need to control. The female serpent would control our intuitive right brain and the male serpent would control our rational left brain. Together, the 2 serpents of Ningishzida would be directly in control of our limbic system comprised of (1) the subcortical limbic system that gives rise to our emotions and (2) the limbic system of the frontal cortex which is responsible for our social intelligence and is associated with our 7th chakra. The presence of Ningishzida might explain why our Kundalini Energy remains dormant until it can be raised by Divine enlightenment. Ningishzida works to keep the Kundalini Energy suppressed so that it does not connect us to the One Divine Consciousness. Rather the pair of serpents works to keep us powerless and connected to serpent consciousness which most likely is satanic.

Da Vinci, as a Freemason, is probably attributing the sacred geometry of the human body to a serpent god rather than to the Infinite Divine Creator. The pentagram, circle, square and equilateral triangle are geometric shapes that the serpent god has snatched from the Divine Creator and then pretends to be the one who incorporates them into the human body shape. This book has shown a striking similarity of the Vitruvian Man to the Vitruvian Martian. Both appear to follow the same basic theoretical model for the construction of the circle, square, pentagram and equilateral triangle. Both use these shapes to celebrate the sacred geometry present in our body shape. However, the similarities end there. The Martian architects attribute the sacred geometry to the Divine Creator and link their creation to 3 progenitors: the Aum sound, a huge vesica pisces symbolized by the giant Alba Mons mountain, and a womb-phallus construct on Pavonis Mons.[4] Da Vinci attributes the sacred geometry to a serpent god. Instead of being in the likeness of the Divine Creator, he has the Vitruvian Man being in the likeness of an all-controlling serpent god which enslaves humanity.

In summary, Da Vinci's Vitruvian Man drawing is a perversion of a very spiritual depiction of our creation by the Absolute Divine Being. The Martians considered themselves to have been created by 3 primordial forces: (1) the Aum sound to produce energy waves in the form of harmonics and irrational numbers, (2) a vesica pisces to provide a life force and (3) a womb-phallus duality to create a zygote.[4] The Vitruvian Martian represents how the Martian body shape was formed by sacred geometry using the sacred irrational constants of π, φ, $\sqrt{2}$, $\sqrt{3}$, $\sqrt{5}$. Their body was shaped to fit a circle, a square, an equilateral triangle and a pentagram. The circle uses π, the square uses $\sqrt{2}$, the equilateral triangle uses $\sqrt{3}$ and the pentagram uses φ, $\sqrt{5}$ and π. The Vitruvian Martian was most likely created

according to the new theoretical model described in Chapters 1 and 2. Da Vinci twisted the Vitruvian Martian sculpture and the theoretical model to proclaim the rulership of a satanic serpent god over the human race. He altered the theoretical model to create a device to point to the pentagram which he hid as a sex cult symbol, and he altered the body shape so as to fit a dual serpent god. By doing so he falsely attributes our creation to a serpent who infringed on the Divine copyright for the purpose of oppression and slavery. The serpent likely made relatively small changes in fully human DNA possibly taken either from the earlier inhabitants of the planet Earth, or from the inhabitants of Mars, which the serpents, as aggressors, probably conquered in a hugely destructive war. The serpent god most likely altered our DNA in order to block many of our capabilities, and to install a controllable reptilian brain into our central nervous system. This would enable the serpent god to use humans for the purpose of slavery, and to satisfy its narcissistic need to be worshipped. The linking of the pentagram with Ningishzida may be showing us that the Freemasons worshipped this serpent god (who likely is an agent of Satan or a representation of Satan himself) by performing deviant sex. Da Vinci is validating the serpent's theft of sacred geometry by attributing the geometric forms to this fraudulent god rather than to the Absolute Divine Being. He is saying that we are created in its image rather than in the Divine image.

The Vitruvian Man drawing has been used extensively in advertising and for logos. It is even inscribed on the 1 Euro coin in Italy. Very few people know its true meaning. Only those very high up in Freemasonry will know that the drawing proclaims rulership of the human race by a serpent god which probably ultimately represents a member of the satanic hierarchy or Satan himself. It is very likely that the main purpose of the drawing was to influence the public in a very subtle way by sending subliminal messages of a perverted use of the pentagram symbol and of the satanic rulership of Ningishzida.

So in addition to being an artist, draftsman, architect, engineer and anatomist, it looks like Da Vinci was a high priest of Freemasonry. He emulates Hermes/Mercury in being a trickster and a deceiver. He celebrated worship to a satanic serpent god, not to the God of Infinite Love and Consciousness. If we hope to free ourselves of the serpent tyranny which Da Vinci was revealing, humanity is going to have to call on the Infinite Divine Being to reclaim us. The serpent has no rightful claim to our life principle which is a unique manifestation of the Divine One within us. The modifications that the serpent has genetically engineered into our DNA to reflect the reptilian mind and reptilian instinctual behaviours is a transgression of the Divine copyright for the

human body and mind. For the serpent to tyrannize and enslave beings whom the Divine has given the powers of free choice and creativity is a crime beyond comprehension.

I believe that we can achieve our independence from the control that Freemasonry represents. We can do so by daily prayer and meditation. We can ask the Divine One to evolve us spiritually thereby taking away the control of demonic forces. We can use love as the motivator of all our thoughts and actions, rather than instincts, emotions or reason. Instincts, emotions and reason can be used to justify any behaviour, even murder. Only love has a conscience. When we meditate, we just have to surrender our spiritual evolution and enlightenment to the Power of the Divine Mother (the Adi Shakti or Holy Spirit), and then quiet down our minds for several minutes so as to not interfere with Her Divine Energy. An era of love, harmony and creativity, not reptilian domination, is our true destiny.

We just have to ask.

References

1. *Intelligent Mars I: Sacred Geometry of the Mountains. Did Da Vinci Know?* Arthur Raymond Beaubien. Epiphi Productions, Ottawa, Ontario, Canada. 2015.

2. *Death by Medicine.* Gary Null, Carolyn Dean, Martin Feldman, Debora Rasio and Dorothy Smith. June 20, 2010.
 https://archive.org/details/DeathByMedicine

3. *"The Caduceus".* Stuart L. Tyson. Scientific Monthly, 34 (6): 495, 1932.

4. *Intelligent Mars III: Aum and the Architect.* Arthur Raymond Beaubien. Epiphi Productions, Ottawa, Ontario, Canada. 2020.

Appendix

Table A1

Model Dimensions for the Theoretical Vitruvian Man		
Parameter	**Formula**	**(mm)**
Circle radius (R)	R	110.256
Da Vinci circle radius		110.000
Top of head to circle centre (model navel)	Rcos(50)	70.871
Top of head to Da Vinci circle centre		71.126
Side length of square (S)	R(1+cos(50))	181.126
Top of head to centre of square	R(1+cos(50))/2	90.563
Top of head to upward arm middle finger	Rsin(50)	84.461
Pentagram line	Rφ	178.397
Pentagram radius	Rφ/(2sin(72))	93.789
Top of head to pentagram horizontal line	R[cos(30)+cos(50)-cos(18)]	61.496
Top of head to centre of pentagram	Rφ[1/(2sin(72))-cos(18)] + R[cos(30)+cos50)]	90.478
Top of head to star point tip above head	φRcos(18) - R[cos(30)+cos50)]	3.311
Height of a pentagram star point	Rcos(18)/φ	64.807
Side of a pentagram star point	R/φ	68.142
Base of a pentagram star point	R/φ²	42.114
Top of head to centre of triangle	Rcos(50)+R/(2cos(30))	134.527
Height of triangle	Rcos(30)	95.484
Top of head to base of triangle	Rcos(50)+Rcos(30)	166.355

Notes:

(1) The capital letter R is used in this table for the model circle radius rather than the lower case r as in the body of the book. It should not be confused with the planetary radius of Mars.

(2) The last line of the table (Top of head to base of triangle) *gives the height of the man when the legs are spread apart.*

(3) Note that all of the parameters except Da Vinci's circle radius and the distance to his circle's centre from the top of the head are functions of R, the model circle radius.

Table A2

Model Dimensions for theTheoretical Vitruvian Martian

Parameter	Formula	(km)
Circle radius (R)	R	924.540
Top of head to circle centre	Rcos(50)	594.283
Top of head to centre of square	R(1+cos(50))/2	759.411
Top of head to upward arm middle finger	Rsin(50)	708.238
Pentagram radius	Rφ/(2sin(72))	786.460
Top of head to pentagram horizontal line	R[cos(30)+cos(50)-cos(18)]	515.668
Top of head to centre of pentagram	Rφ[1/(2sin(72))-cos(18)] + R[cos(30)+cos50)]	758.698
Top of head to star point tip above head	φRcos(18) - R[cos(30)+cos50)]	27.763
Height of top pentagram star point	Rcos(18)/φ	543.431
Base of a pentagram star point	R/φ²	353.143
Top of head to centre of triangle	Rcos(50)+R/(2cos(30))	1128.066
Height of triangle	Rcos(30)	800.675
Top of head to base of triangle	Rcos(50)+Rcos(30)	1394.958
Square Sides		
Top and bottom sides of square	R(1+cos(50))	1518.822
NE side (NW corner to Ascraeus Mons)		1452.338
SW side (SW corner to Arsia Mons)		1542.627
Triangle Sides		
Base of triangle	R	924.540
Right foot to navel		919.498
Left foot to navel		936.126
Pentagram Lines		
Horizontal pentagram line	Rφ	1495.937
Right foot to SW star point		1496.036
Right foot to star point above head		1483.650
Left foot to NE star point		1488.559
Left foot to star point above head		1511.599

N.B. *All dimensions without a formula are those which are distorted by the placement of the model on a spherical surface. R signifies the radius of the circle.*

Table A3

Coordinates and Angles of the Vitruvian Martian Geometric Shapes

Geometric Shape	Coordinates		Interior Angle (°)
Square			
Ascraeus Mons corner	255.5235 °E	11.2874 °N	92.3103
Arsia Mons corner	238.6704 °E	8.0895 °S	90.7606
SW corner	218.6938 °E	8.6764 °N	89.2394
NW corner	236.4632 °E	28.0533 °N	87.6897
Midline at Pavonis Mons	247.0769 °E	1.5989 °N	
Midline at Olympus Mons	227.3272 °E	18.3649 °N	
Centre	237.3299 °E	9.9819 °N	
Circle			
Centre (navel)	239.4633 °E	8.1591 °N	
Triangle			
Navel vertex	239.4633 °E	8.1591 °N	61.0633
Right Foot vertex	234.4174 °E	22.8951 °N	59.0728
Left Foot vertex	223.7230 °E	11.1000 °N	59.8639
Centre	232.5202 °E	14.0514 °N	
Pentagram			
Right Foot star point tip	234.4174 °E	22.8951 °N	35.2501
Left Foot star point tip	223.7230 °E	11.1000 °N	35.8161
NE star point tip	248.9293 °E	16.8337 °N	35.9338
Head star point tip	247.4312 °E	1.2924 °N	37.0449
SW star point tip	232.2012 °E	2.2512 °S	35.9552
Centre	237.3391 °E	9.9740 °N	

Pentagram Pyramid Coordinates
231.6338° E 3.1046° N

Other Books by the Author

Important background material to help understand *Da Vinci's Vitruvian Man Hides a Pentagram and a Serpent God. Basic Model Copied From Mars?* is to be found in a 3-volume series entitled *Intelligent Mars*. These books show that contrary to NASA's indoctrination that Mars is a lifeless planet which has never been home to intelligent life, the vast majority of the topography of Mars is the product of intelligent engineering. Mountains, craters, the Valles Marineris, the Hellas Basin etc. have all been deliberately created to make a huge sculpture out of the entire planet that has a very spiritual message. Like sacred scripture, it tells of creation and possibly depicts the arduous journey of the individual soul through countless reincarnations until it reaches a state of worthiness which allows it to escape the karmic cycle. The Vitruvian Martian is the centerpiece of this sculpture. Da Vinci has perverted its message to proclaim the rulership of a serpent god who has usurped the Divine patent for the human species.

Intelligent Mars I

Sacred Geometry of the Mountains

Did Da Vinci Know?

Arthur Raymond Beaubien

Intelligent Mars is a 3-volume series devoted to the study of Martian topography. The key finding of this work is that the landscape did not come about solely by natural processes but has been largely engineered by a highly advanced civilization many eons ago.

Using special techniques to obtain accurate coordinates of mountain positions, it is shown in *Intelligent Mars I* that the major mountains on Mars are artificially arranged in sacred geometric patterns. One of the patterns is the arrangement of Olympus Mons and the 3 Tharsis Montes which is probably best explained by Da Vinci's drawing of the Vitruvian Man. Another 14 mountains create many more patterns.

Among other things, this book brings evidence for an ancient Martian prime meridian, demonstrates that earth was visited by beings connected to Mars, and reveals the existence of a huge pyramid in the shape of a pentagram. The wealth of new information provided forces us to re-evaluate our entire knowledge base, including the current theory of evolution regarding our own origins. Many will find this to be very unsettling, but we have to meet the challenge and change our behaviours if we hope to coexist with the unquestionable presence of vastly more advanced species in our universe.

It would seem preposterous to question the assumption that the craters on Mars came about by meteoric bombardment of the planet over billions of years. Yet careful study reveals that the shape, size and location of many of the craters create a hidden code which tells us that such craters must have been engineered into existence rather than manufactured from natural forces. A major message that they hide is the expression of sacred geometry in the form of irrational numbers, music intervals and geometric shapes.

The key to breaking much of the code lies in the discovery of ancient prime meridians, prime latitudes and multiple degree systems which were used by the early inhabitants of Mars. From these, numbers which were considered sacred to the architects show up in the coordinate values of crater centres and in the structural components of geometric shapes which can be fit to crater features.

Certain astonishing craters have been created for specific purposes such as to mimic an eye which "views" the giant mountain sites from a great distance. *Intelligent Mars II* demonstrates that the craters on Mars provide us with a unique insight into the spirituality and awesome technical capabilities of the ancient Martian civilization.

Intelligent Mars III totally demolishes the premise that Mars is a natural planet which has never been home to intelligent life. The astonishing truth is that Mars is a massive spherical sculpture which encodes sacred scripture in its landscape. Its topography tells the story of creation by a primordial Aum sound and other progenitors. The sculpture also includes Alba Mons, the Valles Marineris and the Hellas Basin, likely to depict the evolutionary journey of the soul through several lifetimes. The full 3D image is so encompassing that one is led to conclude that the entire planet must have been created in a planet factory by an advanced civilization many orders of magnitude beyond our own in technical capabilities.

Much of the Martian topography from mountains to craters is meticulously placed to honour sacred geometry. Artificiality is readily revealed by (1) a set of ancient prime meridians and unique degree systems (2) groove lines with a constant bearing angle of 7.5° extending intermittently for up to 2500 kilometers (3) over 100 arrow-shaped craters (4) more than 25 calibration markers of degrees visible from outer space and (5) landmarks honouring π, φ, e, $\sqrt{2}$, $\sqrt{3}$ and $\sqrt{5}$. The profound understanding of Aum and sacred geometry displayed by the ancient Martian civilization has many lessons for humanity.

CPSIA information can be obtained
at www.ICGtesting.com
Printed in the USA
BVHW021101200721
612367BV00001B/2